RON MUECK

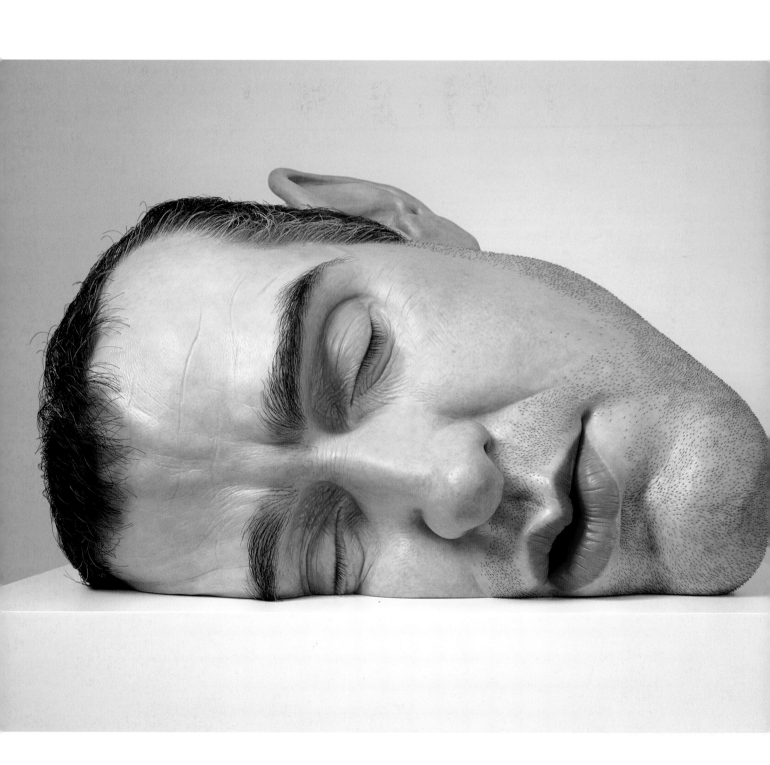

# RON MUECK

herausgegeben von / edited by HEINER BASTIAN

**Editor's Acknowledgements**

I am most grateful for the commitment and generosity of the artist. Anne and Anthony d'Offay and their assistant Laura Ricketts provided invaluable advice and competent expertise to help realize this project and the accompanying publication. I am especially indebted to Anne d'Offay for writing the English version of my text and certainly improving it.

For their cooperation and dedication to this project I would like to thank the following individuals: Laura Ricketts, Anne and Anthony d'Offay, Susanna Greeves, Laetitia von Baeyer, Caroline Käding, Antje Dallmann, Annette Kulenkampff, Ute Barba, Tas Skorupa, Ingrid Nina Bell, Andreas Platzgummer, Keith Sachs, Jannet de Goede, Pamela Griffin, Hedda Reinhardt, and Natalia Tschowri.
My special thanks go to Céline Bastian.

# Inhalt / Contents

# Vorwort

Die außergewöhnlichen Skulpturen des australischen Künstlers Ron Mueck, die in den neunziger Jahren weitgehend unbeobachtet entstanden, wurden erstmals 1997/99 in der Wanderausstellung *Sensation* einem größeren Publikum vorgestellt. Bereits 1996 war Ron Muecks Figur *Pinocchio* die überraschende und vielfach bewunderte Skulptur in der Londoner Ausstellung *Spellbound* der Hayward Gallery gewesen. Die Arbeiten des heute in London lebenden Künstlers erregten sogleich internationales Aufsehen, weil sie sich durch eine schier unfassbare Wirklichkeitsnähe auszeichneten und zugleich eine schwer zu deutende, rätselhafte Magie besaßen. So konnte man in der Ausstellung *Sensation,* die 1998 auch im Hamburger Bahnhof Station machte, mit *Dead Dad* dem toten Vater des Künstlers begegnen. Ron Mueck hatte »das Bild« des Vaters in hoher Perfektion wiedergegeben, jedoch die Körpermaße radikal verkleinert. Eine lebensechte, zugleich seltsam entrückte Figur lag vor dem Betrachter auf einem klassischen Skulpturenpodest. Anrührende Nähe und betonte, konzeptuelle Distanz treffen in Ron Muecks Arbeiten unvermittelt aufeinander.

Seitdem war der Künstler mit seinen Werken in zahlreichen internationalen Ausstellungen vertreten, im Jahr 2001 auch mit seiner überlebensgroßen Skulptur *Boy* auf der Biennale von Venedig. Die Nationalgalerie im Hamburger Bahnhof widmete dem Künstler 2003 die erste Einzelausstellung in Deutschland, die anschließend auch im Frans Hals Museum in Haarlem zu sehen war. Neue Werke des Künstlers wurden vorgestellt, darunter die große Figur *Pregnant Woman* und auch die sehr poetische Arbeit *Man in a Boat.* Mit jedem neuen Werk hat sich der Künstler seither einen beginnenden Weltruhm erobert. Ron Muecks Skulpturen zeigen zum ersten Mal die menschliche Figur nicht nur in realistisch-faktischer Genauigkeit, sondern sie weisen auf ein Bild der psychischen Befindlichkeit des Menschen: seine Trauer und Verlorenheit, seine Verletzlichkeit und Vorsehung.

Die von Heiner Bastian zusammen mit dem Hatje Cantz Verlag jetzt in einer zweiten, erweiterten Auflage herausgegebene Monografie bleibt die erste zusammenfassende, unübertroffene Publikation zum Werk. Das Buch beinhaltet neben vorzüglichen Abbildungen, Texten von Susanna Greeves und des Herausgebers ein von Céline Bastian sorgsam bearbeitetes und jetzt für diese Neuauflage ergänztes Verzeichnis aller bisher entstandenen Werke des Künstlers. Es ist damit eine Publikation zu Ron Mueck, die über die erste Ausstellung in Deutschland hinaus Bestand hat.

PETER-KLAUS SCHUSTER
Generaldirektor der Staatlichen Museen zu Berlin

# Foreword

The extraordinary sculptures created by the Australian artist Ron Mueck during the 1990s were only seen by few until near the end of the decade. They were first presented to a broader public in the touring exhibition *Sensation* in 1997–99. In 1996, Mueck's figure *Pinocchio* had surprised and enchanted visitors to the *Spellbound* show at the Hayward Gallery in London.

The works of this artist, who now lives in London, attracted immediate international attention as incredibly lifelike sculptures which nevertheless possessed an enigmatic, magical quality that defied facile interpretation. One of the sculptures featured in the *Sensation* exhibition, which was also shown at the Hamburger Bahnhof in 1998, was Mueck's *Dead Dad*. Ron Mueck presented us with an image of his father in astonishingly perfect detail but with radically reduced proportions. A lifelike yet strangely enraptured figure lay on a classical sculpture pedestal before the viewer's eyes. Ron Mueck's art juxtaposes touching closeness and emphatic conceptual distance without mediating between the two.

The artist has since shown works at a number of international exhibitions, including the 2001 Venice Biennale, where he exhibited his large-scale sculpture entitled *Boy*. In 2003, the Nationalgalerie im Hamburger Bahnhof presented Ron Mueck's first solo exhibition in Germany, and the show subsequently traveled to the Frans Hals Museum in Haarlem. The exhibition featured recent works, including the large figural sculpture *Pregnant Woman* and Mueck's highly poetic *Man in a Boat*.

Since then, the artist's fame around the world has increased steadily with each new work. Ron Mueck's sculptures are the first to show the human figure not only with factual precision, but also with an image of the psychic state of humanity: sorrow, desolation, vulnerability, and hope.

The first edition of this monograph edited by Heiner Bastian and produced in collaboration with Hatje Cantz Publishers was the first comprehensive publication on Mueck's work; this second, revised edition is still unsurpassed.

In addition to the many excellent illustrations and essays by Susanna Greeves and the editor, the catalogue also contains a meticulously edited first survey of the artist's work prepared by Céline Bastian that was updated for this new edition. It is thus a publication devoted to Ron Mueck that will continue to be read by scholars and art-lovers alike long after the first German exhibition comes to an end.

PETER-KLAUS SCHUSTER
Director General of the Staatliche Museen zu Berlin

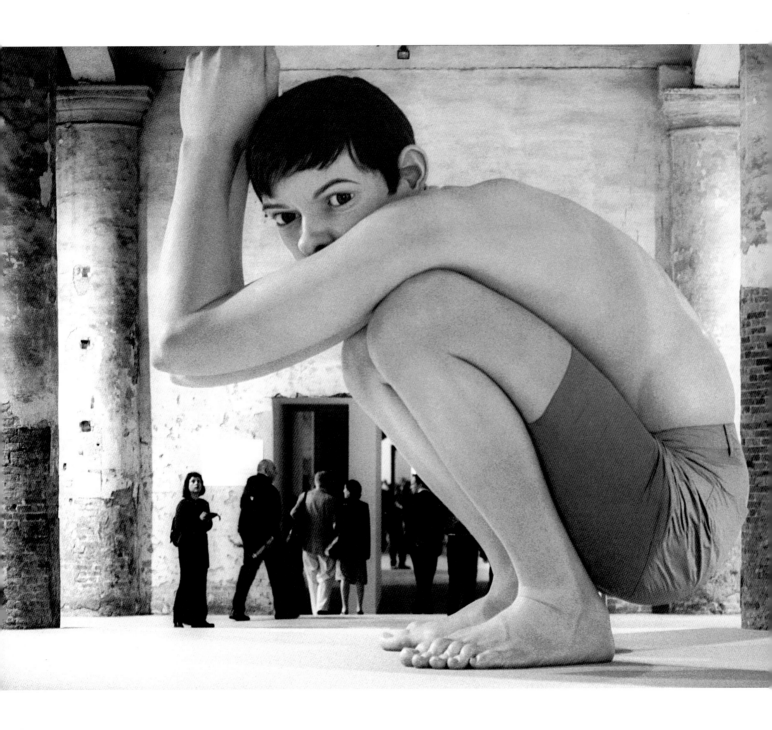

**14 Boy** 1999
Mixed media
490 x 490 x 240 cm; 193 x 193 x 94 ½ in.
Kunstmuseum Aarhus

# Ron Mueck – Realismus neu definiert SUSANNA GREEVES

Die Besucher der Ausstellung *Spellbound,* die 1996 in der Londoner Hayward Gallery gezeigt wurde, waren einigermaßen überrascht, als sie zwischen den großformatigen Bildern von Paula Rego auf die Figur eines kleinen Jungen stießen – nackt bis auf die Unterhose und mit schelmischem Blick. Nichts erklärte die Anwesenheit der Skulptur, doch wer wissbegierig genug war, fand die Antwort in den Zeitungsartikeln, die im Vorraum der Ausstellung zu lesen waren. Rego hatte ihren Schwiegersohn, den Modellbauer Ron Mueck, gebeten, während er selbst an seinem *Pinocchio* arbeitete, für ihr Gepetto-Bild Modell zu sitzen. Mueck schuf jedoch keine Puppe, sondern einen sehr realen Jungen, der sich unter Regos Röcken unangekündigt in die Welt der Kunst schlich. Die Parallele zum Märchen ist frappierend. Um seinen Lebensunterhalt zu sichern, legt der arme Gepetto seine ganze Meisterschaft in das Anfertigen einer Holzpuppe, die – höchst lebendig – fortan eine Lücke in seinem Dasein schließen sollte. Mueck, der als Modellbauer für Film, Fernsehen und Werbung Karriere gemacht hatte, war zwar keineswegs mittellos, mit seiner Rolle als bloßer Auftragnehmer jedoch zusehends unzufrieden und unausgefüllt. So hatte er begonnen, zum eigenen Vergnügen Figuren zu modellieren. Auch Muecks *Pinocchio* sollte das Leben seines Schöpfers einschneidend verändern und ihn zu einem Bildhauer »lebender« Skulpturen machen.

Auftritt Charles Saatchi, die bekannte, gute Fee der Young British Artists: Hingerissen von *Pinocchio,* stöberte er Mueck auf und kaufte schließlich dessen *Big Babies,* seinen *Angel* und *Dead Dad.* Diese Skulptur war in der *Sensation*-Ausstellung der Royal Academy 1997 (1998 im Hamburger Bahnhof in Berlin) Muecks erstes offiziell gezeigtes Werk und stahl den anderen Exponaten die Schau, während es seinen Schöpfer in die erste Riege zeitgenössischer Künstler katapultierte. Die im Frühjahr 2003 in der Londoner National Gallery und im Herbst – erneut im Hamburger Bahnhof – stattfindende Ausstellung bietet nun die Gelegenheit, einerseits auf das bisherige Schaffen des Künstlers zurückzublicken und es andererseits auch im Licht früherer Versuche zu betrachten, in denen die menschliche Figur lebensecht dargestellt wurde.

Ron Mueck produziert makellose, hyperrealistische Figuren, wie sie in der Geschichte der Kunst einmalig sind. Er ahmt die Natur so wirkungsvoll nach, dass die Kategorien Kunst, Abbild und Wirklichkeit aufgehoben zu sein scheinen. In Gegenwart einer Mueck-Skulptur staunen wir über die perfekte Illusion: Wir beugen uns vor – doch egal, wie nah wir ihr sind, wir finden nichts an ihr auszusetzen. Aus den Poren sprießen Härchen, die Augen glänzen feucht, die Haut ist gerötet oder fleckig. Neue Entwicklungen in der Kunst werden oft als technische Fortschritte dargestellt,

9

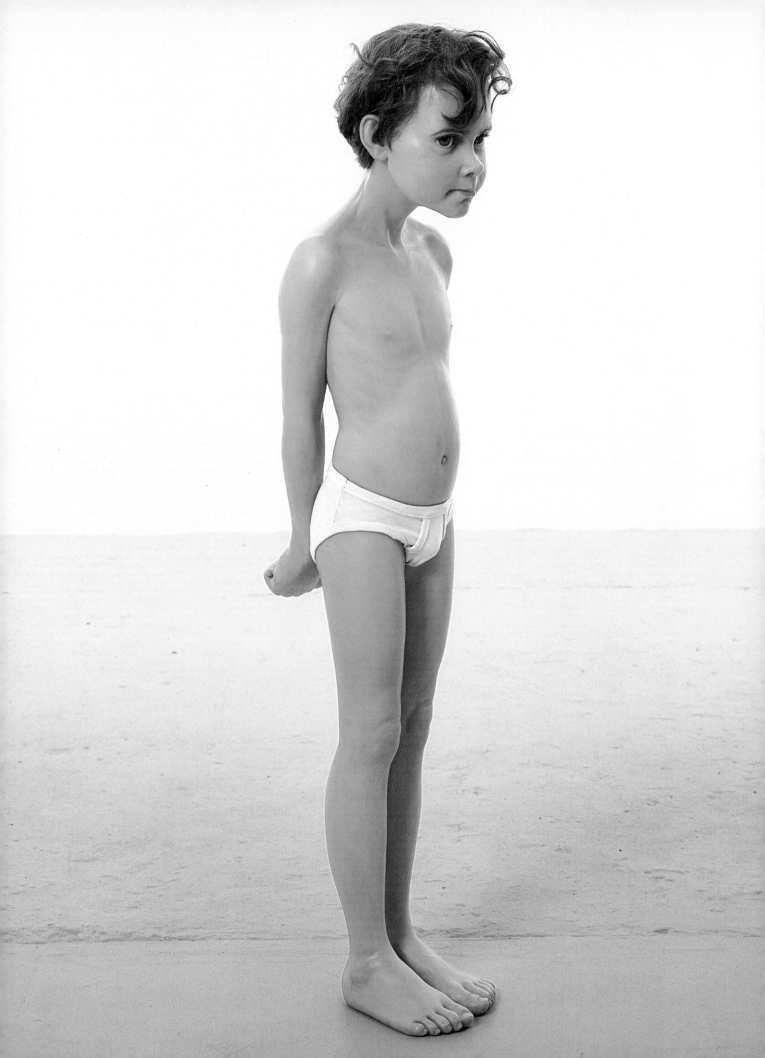

die dem Wunsch nach größerem Naturalismus entspringen. Allerdings wird dieser Impuls seit jeher von einer tief sitzenden Aversion gegen allzu Lebensechtes gedämpft, ein Unbehagen, das in unserer Reaktion auf Muecks Figuren immer noch präsent ist. Genauso wie die Bildhauerei wegen ihrer Wirkungen im Lauf der Geschichte geschätzt wurde, so wurde sie auch geschmäht – wegen ihrer Direktheit, ihrer Fähigkeit anzurühren und Empathie zu wecken. Die abendländische Geschichte der Bildhauerei ist folglich immer auch verbunden mit einer Debatte um die Definition und Parameter der Begriffe »Naturalismus« und »Realismus«. Das Streben nach naturalistischer, realistischer Darstellung hat einerseits die idealisierten Figuren der Hochrenaissance hervorgebracht, in der körperliche Schönheit mit moralischen Vorzügen oder göttlichen Eigenschaften gleichgesetzt wurde, und andererseits die gequälten Leidensfiguren, die die mittelalterliche Bildhauerei zum Schauplatz der christlichen Lehre machte. »Realismus« kann die getreue Darstellung der essenziellen, universellen Natur oder der detaillierten Beobachtung einer bestimmten Wirklichkeit sein, Schönheit in ihrer reinsten Form zeigen oder dieser eine Absage erteilen. Muecks Hyperrealismus ist nicht »einfach« die perfekte, technische Nachahmung der Wirklichkeit, sondern verlangt nach einer anderen Definition.

## Ähnlichkeit: Technik und Tabu

Vor einer Skulptur von Ron Mueck beschleicht uns ein unbehagliches Gefühl (und wenn man – allein – in einer dunklen Galerie mit seinen Werken steht, wird einem geradezu unheimlich). Nicht, dass wir wirklich glauben, sie seien lebendig; wir zucken auch nicht zusammen, wie wir es tun, wenn wir aus dem Augenwinkel einen lebensgroßen Dummy erblicken. Die Begegnung mit Muecks illusionistischem Leben hat tiefere und anhaltendere Wirkung, weil wir bei diesem Täuschungsmanöver bereitwillig mitspielen. Unser Staunen gründet sich auf das Bewusstsein, getäuscht zu werden, und das Vergnügen besteht darin, genau dies herauszufinden. Die widersprüchlichen Botschaften von Auge und Verstand, das Zweifeln an unseren Sinnen gefallen uns. Der unwiderstehliche Drang, die Figuren anzufassen, den alle Besucher zu verspüren scheinen, entspringt dem Wunsch, der optische Eindruck eines warmen, weichen Lebewesens möge bestätigt werden. Sobald wir uns abwenden – so stellen wir uns vor –, könnte sich einer der gefiederten Flügel bewegen, ein angehaltener Atem entweichen oder ein Lid zucken, und der Schauer des Unheimlichen lässt uns frösteln. Der Verstand sagt uns, dass es künstliche Figuren sind, und dennoch entsteht aus dem Konflikt zwischen der Trägheit des Materials und seiner

**2 Pinocchio** 1996
Mixed media
84 x 20 x 18 cm; 33 x 7⅞ x 7⅛ in.
Collection John and Amy Phelan

11

scheinbaren Lebendigkeit Spannung; die Furcht vor dem Lebensechten und den damit verbundenen widerstreitenden Wahrnehmungen des Bildes als Abbild und des Bildes als Wirklichkeit lassen uns nicht mehr los.

Woran liegt es, dass die lebensechte Darstellung der menschlichen Figur uns derart fasziniert und aus der Ruhe bringt? Richten wir den Blick auf eine andere Geschichte, die von einem Mann handelt, der die Fertigkeit seiner Hände und die Sehnsucht seines Herzens vereint, um einem Kunstwerk Leben einzuhauchen: die Erzählung von Pygmalion und Galatea. Sie begründet den Mythos der abendländischen Bildhauerei und des paradigmatischen Schöpfungsaktes. Als Pygmalion, der sagenhafte König von Zypern, sich unsterblich in die von ihm selbst geschnitzte Statue einer schönen Frau verliebte, erweckte Venus diese zum Leben. Die Geschichte beschreibt die magische Verwandlung einer dreidimensionalen, geschnitzten Figur in ein lebendes, atmendes Wesen. Ähnliche Mythen finden sich auch in anderen Kulturen, und die Geschichten vom menschlichen Wunsch, ein lebendes Wesen zu erschaffen, treten in vielerlei Gestalt auf: Man denke an den Golem in der jüdischen Überlieferung, an Descartes' Automaten Francine und an Frankensteins Monster. Sie alle sind Allegorien auf die dem kreativen Akt innewohnenden Erfolge und Gefahren – doch vor allem sind sie Ausdruck unseres Bewusstseins, dass wir mit der Erschaffung einer menschlichen Figur den göttlichen Schöpfungsakt parodieren. Das Tabu, das verhindert, dass die Darstellung dem Leben zu nahe kommt, sitzt tief. Die abendländische Ästhetik und Philosophie gründen auf der platonischen Ideenlehre, nach der eine exakte Darstellung nicht möglich und auch nicht erstrebenswert ist, und wir sind von Jahrhunderten des Bilderstreits und der Bilderverbote geprägt. Der Pygmalion-Mythos besagt, dass die Reaktion des Menschen auf Kunst, speziell auf die dreidimensionale, menschliche Figur, Folgen haben kann. Wir alle wissen, dass Menschen von Skulpturen erregt werden können, dass sie zu ihnen beten und Wallfahrten unternehmen, sie zertrümmern und vom Sockel stürzen, durch sie zur Ruhe finden oder gar zu Revolutionen aufgewiegelt werden. Der demokratische, direkte Reiz einer Skulptur, die seltsame, verführerische Anziehungskraft ihrer Dinghaftigkeit waren schon immer Ursache für intellektuellen Argwohn und Widerwillen und haben zu der Negativbewertung geführt, mit der die Naturtreue bisweilen belegt wurde. In einem Aufsatz mit dem kompromisslosen Titel »Warum die Bildhauerei ein Ärgernis ist« diagnostiziert Charles Baudelaire eine weit verbreitete Vorliebe für die »brutale und positive« Bildhauerei,[1] und seine Attacke ist nur eine von vielen in einer langen, historischen Debatte, die der Malerei immer den Vorzug vor der Bildhauerei gab.

7  **Angel**  1997
Mixed media
Figure: 110 x 87 x 81 cm;
43 1/4 x 34 1/4 x 31 7/8 in.
Stool: 60 x 40 x 38 cm;
23 5/8 x 15 3/4 x 15 in.
Marguerite and Robert Hoffman, Dallas

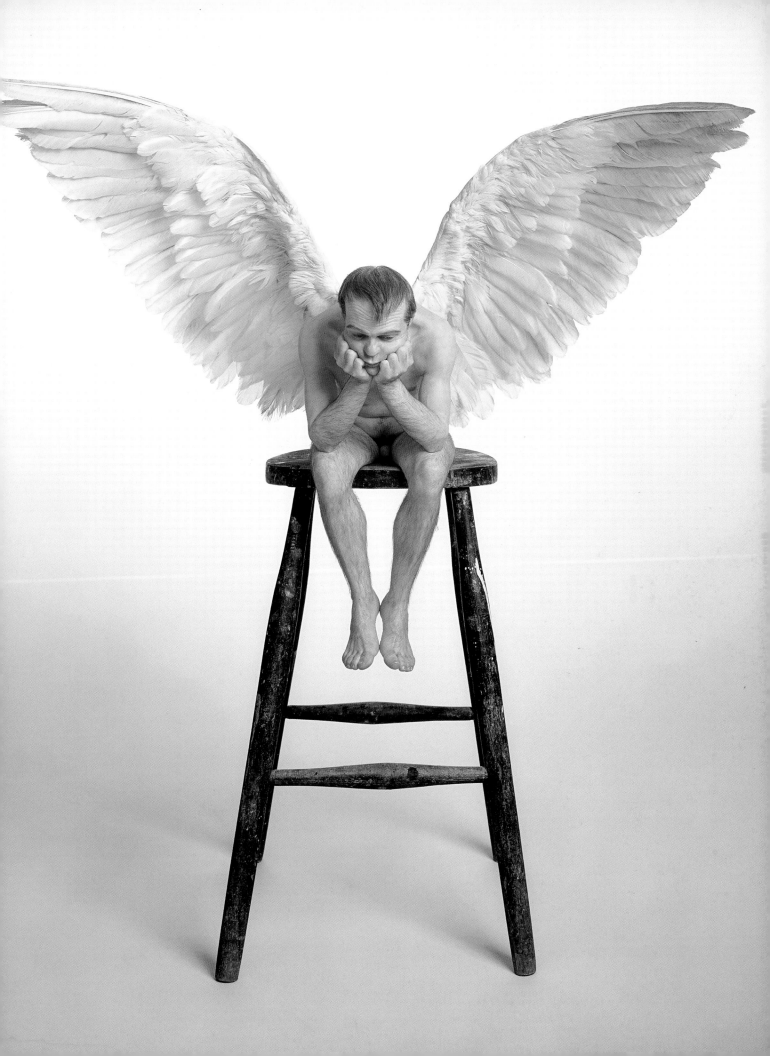

Ein damit verwandtes Vorurteil, das ebenfalls bis in die Antike zurückreicht, ist der Glaube an das Primat des Auges vor den übrigen Sinnen. Der Tastsinn, der von Muecks Darstellung warmen, menschlichen Fleisches oder feinen Haarflaums am stärksten angesprochen wird, galt immer als unzuverlässig, gefährlich und sogar moralisch zweifelhaft. Gleichzeitig ist es das älteste und abgedroschenste Kompliment, einem Künstler zu bescheinigen, er könne Marmor wie Fleisch und Blut aussehen oder eine Skulptur atmen und sich bewegen lassen. Daidalos, mythischer Ahnherr der griechischen Kunst, hat angeblich Statuen geschaffen, die von ihrem Sockel gestiegen sind. Wie wörtlich diese Sage genommen wurde, zeigt sich in den ausgegrabenen Figuren, deren Fußgelenk an ihre Sockel gekettet waren. Die antiken Texte sind voller bewundernder Anekdoten über die Täuschungskünste von Malern und Bildhauern – so malte Zeuxis Trauben, an denen die Vögel pickten, oder das Kalb, das neben Myrons Skulptur einer Kuh verhungert ist. Bewundert wurde die Fähigkeit von Statuen, Gefühle hervorzurufen – bis hin zu Gewalt und sexueller Lust (die *Knidische Aphrodite,* von Plinius als die »schönste Frauenstatue auf dem ganzen Erdenkreis« gepriesen, hatte angeblich einen Fleck am Schenkel, den ein besonders überwältigter Kunstliebhaber hinterlassen haben soll). Ähnliche Formulierungen finden sich in Berichten über große Bildhauer der Renaissance, und dennoch scheinen sie nicht viel mehr als manierierte Klischees, wenn sie etwa in Epigrammen auftauchen, die von Antonio »Canovas errötendem Marmor«[2] schwärmen. Es ist die Dreidimensionalität der Skulptur, die uns in besonderem Maße dazu verleitet, sie irrtümlich als realen Körper wahrzunehmen.

Muecks Arbeiten geben Fleisch, Blut, Haar, Materie und Textur mit atemberaubender Genauigkeit wieder. Wonach halten wir also Ausschau, um zu testen, ob wir es mit einem lebenden Wesen zu tun haben? Als ein erstes Indiz mag Bewegung gelten. Muecks Skulpturen sind unbewegt, aber nicht in der Geste eingefroren: In ruhender Haltung dargestellt, bleibt die Möglichkeit gewahrt, sie könnten sich bewegen. Und wenn wir auf die Augen schauen, empfinden wir ein Porträt oder gar eine Person ohne Augen als schrecklich irritierend. In der chinesischen Tradition vollendet der Maler die Augen der Porträtierten zuletzt, damit sie sich nicht seiner Kontrolle entziehen.[3] So verwendet Mueck außergewöhnliche Sorgfalt auf die von Hand hergestellten Augen seiner Figuren, zieht eine transparente Linse über die farbige Iris und die tiefschwarze Pupille. Wenn er die Augen schließlich einsetzt, ist die Wirkung verblüffend: Die Figur scheint zum Leben zu erwachen. Der leere, glasige Blick einer Wachsfigur verrät ihre Unbelebtheit schnell. Muecks Augen jedoch sehen nicht nur erstaunlich echt aus, sie glänzen unter halb geschlossenen Lidern,

sind halb verdeckt oder blicken gedankenverloren nach unten. Der Eindruck, dass hinter diesen Augen Leben ist, bleibt bestehen.

Bei *Dead Dad* sind die Augen geschlossen. Das graue Haar ist zurückgekämmt aus dem faltigen Gesicht, das zu melancholischer Ruhe erschlafft ist. Dies ist die einzige Skulptur, bei der Mueck uns nicht von der Anwesenheit von Leben, sondern von dessen Abwesenheit überzeugt. Obwohl wir es besser wissen, beschleicht uns das schaurige Gefühl, nicht eine Darstellung zu betrachten, sondern die Sache selbst, einen Leichnam. Jedes Detail wirkt echt, und zugleich wissen wir, dass das einst vorhandene Leben den Körper verlassen hat. In *Dead Dad* kristallisiert sich eine der zentralen Fragen heraus, mit denen sich Muecks Werk auseinander setzt: Was unterscheidet belebte von unbelebter Materie, worin besteht das belebende Element, der Funke, der Leben ausmacht? Craig Raine schreibt: »Ron Muecks bildhauerisches Werk erklärt, warum der Mensch das Bedürfnis hatte, die Idee der Seele zu erfinden.«[4]

## Vom *Kritios-Knaben* zu Muecks *Boy*

Am Anfang der naturalistischen Bildhauerei steht eine einzelne Figur, ein entfernter Vorfahr, dessen Linie sich mehr oder weniger geradlinig bis zu Mueck nachverfolgen lässt. Als »Coverboy der griechischen Wende«, wie er bisweilen genannt wird, signalisiert der *Kritios-Knabe* das Ende einer starren, stilisierten Bildhauertradition und den Beginn einer präzisen Nachahmung der Natur und damit eine der tiefgreifendsten Entwicklungen in der abendländischen Kunst.[5] Die beiden Schlüsselfaktoren in der Wende zur Frühklassik waren technologische Innovation – die Erfindung von Techniken, die größere Detailgenauigkeit ermöglichte – und eine Tendenz zum Narrativen – der Wunsch, den Betrachter durch gelungene emotionale und dramatische Elemente einzubinden, um die jeweilige Story glaubhafter zu erzählen. Diese Grundimpulse wirken auch noch bei Mueck: technische Weiterentwicklung, um eine getreuere Nachahmung der Wirklichkeit zu erreichen und so eine psychologisch überzeugende Präsenz zu vermitteln. Allerdings handelte es sich bei den naturalistischen Figuren der griechischen Frühklassik um Athleten, Helden und Götter. Sie repräsentierten ein Ideal, das durch die Verschmelzung von Menschlichem und Göttlichem, Universalem und Besonderem entstanden war. Die klassischen Prinzipien wurden später von der Renaissance zu mathematischen Regeln kodifiziert, die Proportion und Anatomie, Perspektive und Verkürzung, Komposition und Symmetrie bestimmten. Eines der bekanntesten Werke der Renaissance, die *Proportionsstudie nach Vitruv* von Leonardo da Vinci (1452–1519), illustriert exemplarisch ihren anhaltenden Einfluss auf die abendländische Ästhetik.

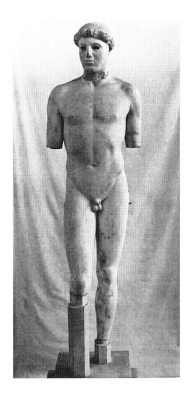

*Kritios Boy,* ca. 480 B.C.
Marble
Height: 86 cm; 33$^{7}$/$_{8}$ in.
Acropolis Museum, Athens

Muecks Werk wirkt so akribisch naturgetreu im Detail, dass man die Freiheiten, die er sich mit genau diesen Prinzipien der Proportion und Anatomie nimmt, nicht sofort erkennt. Mueck arbeitet zwar mit lebenden Modellen, doch die Posen von *Boy, Big Man* und *Shaved Head* hätten Muecks Modelle wohl kaum einnehmen können. Die Figuren sind zu kompakteren Formen »gefaltet«, als dies üblicherweise ohne Anstrengung möglich ist, trotzdem wirkt jede von ihnen entspannt, in stabilem Gleichgewicht und fest am Boden verankert. Lange Arme mit riesigen, klobigen Händen ragen aus dem verknoteten Körper des *Shaved Head,* die Fingerknöchel ruhen auf dem Boden. Wenn wir die Skulptur im Geiste zu voller Höhe aufrichten, können wir uns vorstellen, wie disproportioniert seine Hände im Verhältnis zum Körper sind – eine Reminiszenz an Michelangelos (1475–1564) *David,* dessen riesige Hand anmutig am Oberschenkel ruht. Muecks Skulptur hat die latente Energie und Eleganz eines Athleten, wirkt zugleich in sich verknäult und ruhend, der eingerollte Körper bildet das Gegengewicht zu den langen, schlaffen Armen. Dagegen *Big Man:* Die kompakte Masse der Figur ist in eine Ecke gestopft – eine Fleisch gewordene Manifestation brütenden Elends. Seltsamerweise verleihen gerade die expressiven Verrenkungen Muecks Figuren jene Lebendigkeit, die der Eins-zu-Eins-Abbildung fehlt: Selbst bei einer perfekten, exakten Nachbildung des menschlichen Körpers wirkt eine Plastik immer steif, wie eine tote Hülle. Mueck arbeitet nach dem Leben, nach gefundenen Bildern und anatomischen Lehrbüchern, aber er geht nicht rechnerisch vor. Seine Skulpturen existieren mitunter wochen- oder monatelang in Ton, während er sich um die »richtigen Proportionen« bemüht, die nicht auf der getreuen Nachbildung eines lebenden Modells beruhen, sondern der Figur eigen sind, die er modelliert.

Muecks Figuren sind alles andere als perfekt oder idealisiert: Sie sind ungelenk, mit Schönheitsfehlern behaftet, sie sind sterbliches Fleisch. Seine Wirklichkeit hat die schockierende Ehrlichkeit der Gotik. Mueck zeigt schonungslose Darstellungen des nackten, menschlichen Körpers – und keine Akte. Jan van Eycks (um 1390–1441) *Adam und Eva* wirken splitternackt. Es sind echte Menschen, präzise beobachtet und mit leidenschaftlicher Genauigkeit wiedergegeben. Vom Einfluss des klassischen Griechenland mit seiner Idealisierung, den van Eycks italienische Zeitgenossen nie ganz losgeworden sind, ist hier nichts zu spüren. Van Eyck war ein technischer Neuerer, er entwickelte die Öllasur, um die Wirklichkeit in feineren, leuchtenderen Details abbilden zu können. Das Spektrum seiner optischen Effekte, was Textur und Oberfläche betrifft, ist beeindruckend: Haarflaum, steifer Brokat, handgeblasenes Glas und polierter Zinn sind mit fast unnatürlicher Präzision wiedergegeben. Diese

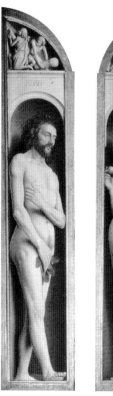
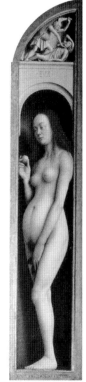

JAN VAN EYCK
*Adam and Eve,* 1432
Oil on wood
350 x 223 cm; 137$^{3}$/$_{4}$ x 87$^{7}$/$_{8}$ in.
(altarpiece when closed)
St. Baafskathedraal, Ghent

16

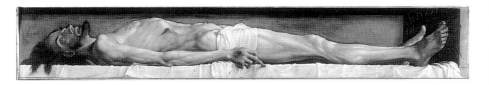

HANS HOLBEIN THE YOUNGER
*The Dead Christ in His Tomb,* 1521
Varnished tempera on panel
30.5 x 200 cm; 12 x 78³/₄ in.
Öffentliche Kunstsammlung Basel,
inv. no. 318

Wirklichkeit ist durch die Entwicklung einer kristallklaren Detailbeobachtung entstanden, nicht durch die meisterhafte Einhaltung der vielen naturwissenschaftlichen Gesetze der Renaissance. Auch Mueck listet den menschlichen Körper in allen Einzelheiten auf, von der schwieligen Ferse bis zum rissigen Fingernagel und der dunklen Halskehle. Muecks Figuren und die harte, brillante Klarheit der realistischen Renaissance des Nordens teilen dieselbe Ästhetik. Man vergleiche *Seated Woman* mit dem Albrecht Dürer (1471–1528) zugeschriebenen Porträt seines siebzigjährigen Vaters oder *Dead Dad* mit Hans Holbeins (1497–1543) schaurigem *Leichnam Christi im Grabe* mit glasigem Blick, die Hand zur Klaue erstarrt.

In der Renaissance entstanden zwei streng getrennte Schulen, die gotische des Nordens und die griechisch-römische des Südens, für die die iberische Halbinsel keine Rolle spielte. Die Kunst, die – vom restlichen Europa ignoriert oder für wertlos erachtet – ab dem 15. Jahrhundert dort entstand, arbeitete mit der beunruhigenden Wirkung des Hyperrealen. In der polychromen Plastik der spanischen Renaissance schufen Bildhauer und Maler gemeinsam extrem naturalistische, holzgeschnitzte Figuren, die mit Gesso – einer Grundierung – überzogen, poliert und bemalt wurden und zuletzt Augen aus Glas, Zähne aus Elfenbein und echtes Haar erhielten sowie mit Kleidern und Schmuck ausgestattet wurden. Gregorio Fernández (1576–1636), der Meister der Valladolid-Schule aus dem 17. Jahrhundert, dämpfte die grell bunten Farben und nahm die übertriebenen Gebärden seiner Vorgänger zurück. Sein *Ecce Homo* fordert uns auf, Christus schlicht als Mensch zu betrachten, und konfrontiert uns mit einer lebensgroßen Figur, die aus Fleisch und Blut zu sein scheint. Höhepunkt dieser Tradition bilden neben denen von Fernández die ebenfalls exquisit modellierten und akribisch detailgenauen Werke seines Zeitgenossen Juan Martinez Montañes (1568–1649). Beide perfektionierten ihre Technik, menschliches Fleisch zu malen. Sie berücksichtigten jedes noch so winzige Oberflächendetail, jede stoffliche Substanz, um pulsierende Adern und angespannte oder schlaffe Muskeln unter der Haut wiederzugeben. Es ging darum, Figuren von größtmöglicher körperlich-sinnlicher Präsenz zu schaffen, die so real wirkten, als seien sie Darsteller in einem narrativen Drama. Für sie wäre die Jungfrau Maria eine verzweifelte Frau mittleren Alters gewesen, jedoch keine klassische Venus mit Kind.

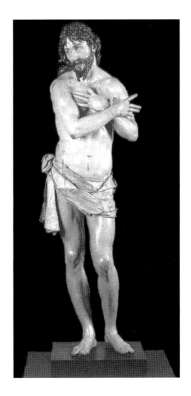

GREGORIO FERNÁNDEZ
*Ecce Homo,* 1617, Polychrome wood
Height: 168 cm; 66¹/₈ in.
Museo Diocesano, Valladolid

17

Indem sie die Grenzen zwischen Kunst und Wirklichkeit und damit die Trennung zwischen Figur und Betrachter bewusst aufhoben, wollten sie die Gefühle und Instinkte des Betrachters für die religiöse Botschaft empfänglich machen. Indem sie die idealisierte Ästhetik ablehnten, wollten sie echte, menschliche Gefühle, echtes Leiden verkörpern, und der Erfolg des Künstlers wurde an den Tränen und der Begeisterung der Betrachter gemessen. Dabei hatten sie nicht nur die Ungebildeten und Gläubigen im Auge, auch Mäzene und Kenner schrieben bewundernd, sie seien hypnotisiert, hingerissen, überwältigt.

Der hohe Grad an Emotionalität und religiösem Eifer mag uns heute befremden, aber die schockierende Wirklichkeit und Direktheit dieser Skulpturen stehen in offenkundigem Zusammenhang mit Muecks Werk. Die spanischen Bildhauer benützen unsere Verbundenheit mit ihren »echten« Menschen, um universelle (religiöse) Wahrheiten zu vermitteln. Doch Muecks Figuren scheinen genauso zu funktionieren: Auch sie vermitteln universelle Gefühle und Erfahrungen, sie sind höchst persönliche, eigenwillige Darstellungen. Die Spannung zwischen der Wirklichkeit des Kunstobjekts und der Wirklichkeit des Lebens verlangt eine Reaktion, die Gefühl und Erkenntnis integriert. Das heißt, Muecks Werke lösen meist eine Reaktion auf den dargestellten Gegenstand, die wiedergegebene Person aus, wecken Erinnerungen an unsere eigenen, banalen oder tiefen Gefühle und Erfahrungen: Kindheit, die Geburt der eigenen Kinder, Elternschaft, Altern und Tod eines Elternteils. Für diese Art von Reaktion fehlt der formalistischen Kunstkritik von heute das sprachliche Rüstzeug, wenngleich sie für unser Verständnis von Muecks Werk so wertvoll ist wie die sachkundige Wahrnehmung kunsthistorischer Zusammenhänge. Bildhauerei, die die Wirklichkeit imitiert, wurde historisch immer misstrauisch beäugt – mit der Begründung, sie rufe, da sie auf emotionaler und physischer statt auf intellektueller Ebene operiere, eine ethisch minderwertige Reaktion hervor. Diese Unterscheidung scheint bis heute Gültigkeit zu besitzen, wie der gelegentliche Argwohn der Kritiker gegenüber populären, leicht zugänglichen Werken beweist.

Im 18. Jahrhundert wurde die willkürliche Unterscheidung zwischen »high« und »low« geradezu übertrieben. Mit wachsendem Eifer wurden antike klassische Statuen ausgegraben, studiert und gesammelt, und der strahlend weiße Zustand, in dem sie aus der Erde geborgen wurden, bestärkte die von Johann Joachim Winckelmann gepriesene »edle Einfalt und stille Größe«. Gleichzeitig wurden Puppen, Attrappen, Automaten und Wachsfiguren immer populärer, sodass lebensechte Darstellungen des menschlichen Körpers mit »niederer« oder »minderwertiger« Kunst gleichgesetzt wurden. Neue Funde und Erkenntnisse zwangen jedoch gegen Ende

**21  Big Man** 2000
Mixed media
205.7 x 117.4 x 209 cm; 81 x 46 1/4 x 82 3/4 in.
Hirshhorn Museum and Sculpture Garden,
Smithsonian Institution, Washington DC,
Joseph H. Hirshhorn Bequest Fund, 2001

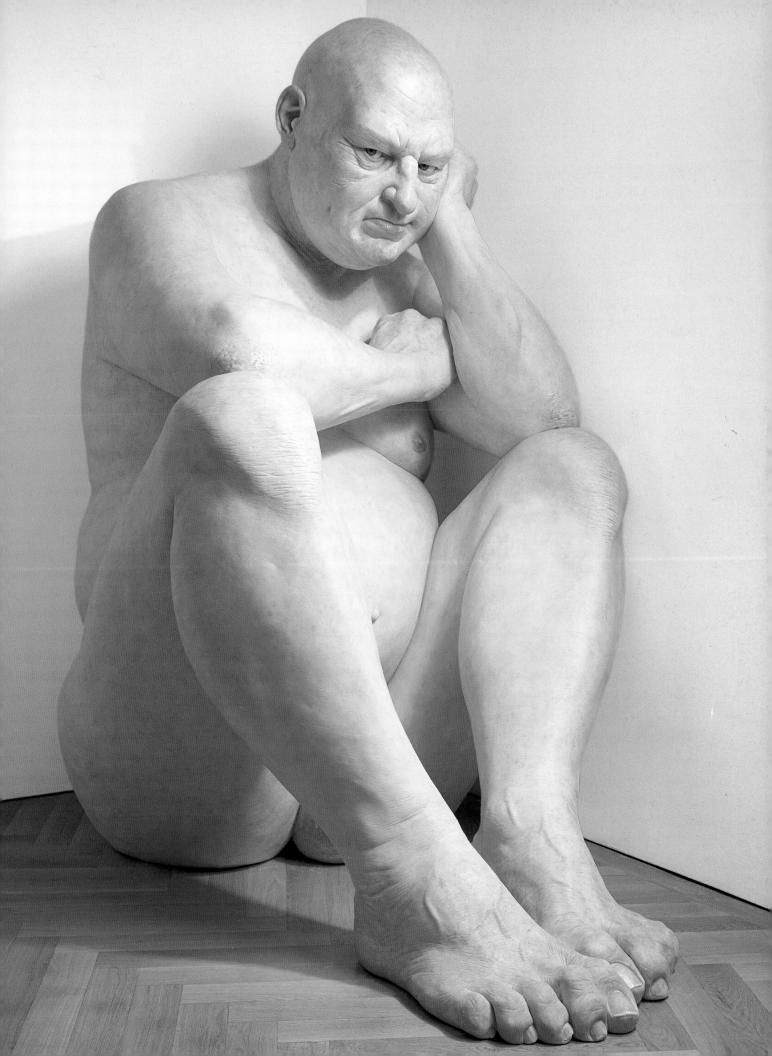

des Jahrhunderts zu einer weit reichenden Neubewertung der Antike.[6] Man entdeckte, dass die vermeintlichen Vorbilder und Verkörperungen der moralisch befrachteten Ästhetik des 18. Jahrhunderts bunt bemalt und verziert gewesen waren: mit Wimpern aus Draht sowie gefärbten Lippen und Brustwarzen. Heute wissen wir, dass sogar der *Kritios-Knabe* einst eingesetzte Augen hatte und der blanke Marmor wahrscheinlich – wie der Parthenon – hautfarben bemalt war. Nachdem sie zuerst die Inspiration für die reinen Marmorstatuen des Neoklassizismus geliefert hatte, ermunterte die Antike das 19. Jahrhundert nun zu einer Reihe von Experimenten mit bemalter, eingefärbter und Mixed-Media-Bildhauerei.

Trotzdem empfand das Publikum, als Edgar Degas (1834–1917) seine *Petite danseuse de quatorze ans* 1881 zum ersten Mal ausstellte, das Werk als zutiefst schockierend. In hautfarbenem Wachs modelliert, trug die Tänzerin ein Tutu und ein Stoffmieder, Strümpfe und Ballettschuhe sowie eine Perücke aus Echthaar, das mit einem grünen Band nach hinten gebunden war (die heute bekannte Bronzefigur entstand erst 1921). Die verwendeten Materialien erinnerten an Karneval und Groteske, an wissenschaftliche Studien und den soeben wieder entdeckten spanischen Katholizismus; die groben Gesichtszüge und die behauptete Unsterblichkeit der Figur lösten bei den Betrachtern Abscheu und Empörung aus. Einer meinte, sie »gehöre in ein zoologisches, anthropologisches oder medizinisches Museum«. Der Kritiker Joris Karl Huysmans diagnostizierte seine persönliche Kehrtwendung: »Der grauenhafte Realismus dieser Statuette erzeugt eine ausgesprochene Unbehaglichkeit; alle Vorstellungen von der Bildhauerei mit ihrem unbelebten, strahlenden Weiß und den denkwürdigen, über Jahrhunderte kopierten Klischees werden über den Haufen geworfen.« Sein abschließendes Urteil lautete, dies sei »die erste wahrhaft moderne Skulptur«.[7] Anstatt ein idealisiertes oder verallgemeinertes Menschsein zu verkörpern, repräsentiert sie, wie Muecks Figuren, einen ganz eigenen, individuellen, nicht romantisch verklärten Typ, dessen Persönlichkeit im keck nach vorne gereckten Kinn zum Ausdruck kommt.

Wie die *Petite danseuse* und die spanischen Heiligen haben Muecks Figuren echte Kleider und echtes Haar. Bei den Beinen von *Dead Dad* sind es sogar des Künstlers eigene Haare (eine Praxis, die er aus nahe liegenden Gründen nicht beibehalten konnte). Dieses zunächst rein praktische Detail verleiht dem Werk die starke Aura der Reliquien- oder Votivbilder von Toten. Da Mueck in der Wahl der Kleidungsstücke und Requisiten äußerst sparsam ist, kommt diesen besondere Bedeutung zu. Manche sind ausgedacht und in passender Größe hergestellt, doch oft handelt es sich um vorgefundene Gegenstände, die Spuren des Gebrauchs aufweisen. Der Kokon um *Man in Blankets* besteht aus einer sauberen, aber abgenutzten wollenen

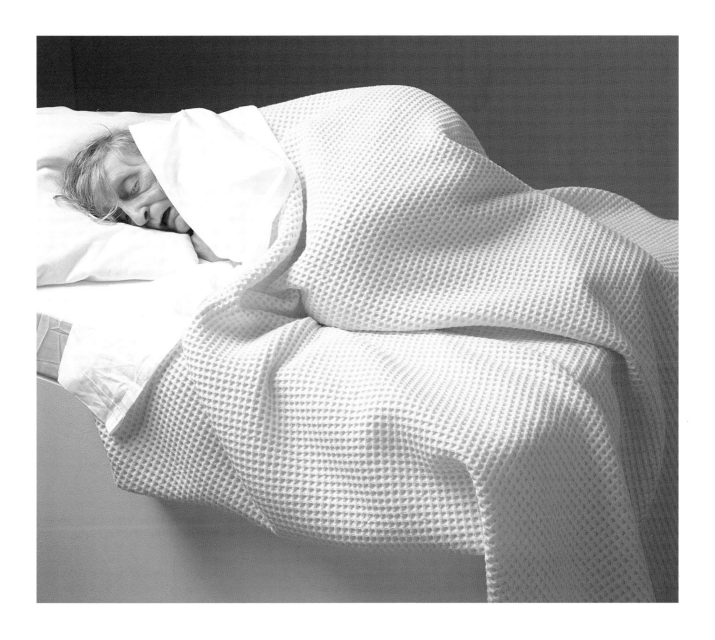

Anstaltsdecke, die mit ihrem Schwarzgrau das Nestinnere verdunkelt; während das Blau und Rosa der äußeren Lagen die schwache Rötung des Gesichts und die bläulichen Adern betonen. Manche Requisiten bergen geheimnisvolle Details, potenzielle Schlüssel zu einer nicht erzählten Geschichte, andere haben unmittelbare, eindeutige Bezüge. *Old Woman in Bed* liegt gekrümmt zwischen sauberen schneeweißen Laken, die eindeutig auf ein Krankenhaus oder Altersheim verweisen. *Seated Woman* trägt ein nagelneues wollenes Twinset und Perlen. Selbst die Krokodillederschuhe mit der goldenen Schnalle und die eleganten Ohrringe hat Mueck speziell für sie gefertigt. Sie sitzt auf einem abgewetzten, verblichenen Brokattuch, das Bilder von Plüschsofas und mit Nippes geschmückten Tischchen heraufbeschwört, und möglicherweise ist es dieses Stück Stoff, das künftige Generationen an sie erinnert.

**17 Old Woman in Bed** 2000
Mixed media
24 x 94.5 x 56 cm; 9 $\frac{1}{2}$ x 37 $\frac{1}{4}$ x 22 in.
Ed. 1/1
National Gallery of Canada, Ottawa

21

## Eine neue Art von Realismus

Realismus bedeutet heute oft die Verwendung realer Gegenstände oder die Konzentration auf reale, verifizierbare, konkrete Eigenschaften, wie im Minimalismus – einen existenzialistischen Realismus, keinen illusionistischen, vorgetäuschten. Selbst die hyperreale, deskriptive Kunst der letzten Jahrzehnte hält sich an unpersönliche Beobachtung und unbedingte Tatsachentreue. Mueck hingegen produziert nicht nur die bis dato absolut vollkommene Illusion von Wirklichkeit, er gibt dem Hyperrealen Subjektivität und Menschlichkeit zurück. In der minutiösen, schonungslosen Darstellung realer, nicht perfekter menschlicher Körper gelingt es ihm zudem, mittels eines wirkungsvollen »psychologischen Realismus« eine innere Geschichte zu erzählen. Schließlich ist die Psychologie der wichtigste Informant heutiger Deutungsversuche: Sie hat politische, mythische und religiöse Konstrukte abgelöst. Muecks Skulpturen sind Porträts von Seelenzuständen, und nach dem anfänglichen Staunen über ihre Lebensechtheit ist es gerade ihr Innenleben, dem unsere anhaltende Aufmerksamkeit gilt. *Ghost* ist die Verkörperung pubertärer Verlegenheit, die Projektion einer Lebensphase, in der uns der eigene Körper plötzlich unförmig, fremd und schrecklich peinlich vorkommt. Zwei Meter groß, mager und mit unreiner Haut, lehnt sich das Mädchen gegen eine Wand, als würde es sich am liebsten hinter ihrem Badeanzug verstecken. *Seated Woman* jedoch porträtiert das Altern. Der Grad an Lebensüberdruss ist so präzise wiedergegeben wie das zarte Liniengeflecht über den transparenten Fingern. Mit dem leicht gesenkten Kopf, den schweren Lidern und dem gekrümmten Nacken wirkt die alte Frau resigniert, aber nicht geschlagen.

Eines der wirkungsvollsten Gestaltungsmittel, die Mueck für seine psychologischen Intentionen verwendet, ist der Maßstab. Seine Figuren scheinen zwar aus demselben Stoff zu sein wie wir, aber sie sind nicht von dieser Welt. Ihre Körpergröße entspricht nicht der des Menschen – wenngleich wir es keineswegs mit Riesen oder Zwergen zu tun haben –, und diese Abweichung von der Norm verleiht ihnen ihre eigene Dimension. Extreme Formate sind in der Bildhauerei mit eindeutigen, historischen Assoziationen verknüpft. Kleine Gegenstände sind wertvoll und oft zum privaten Vergnügen oder Gebrauch bestimmt. Das Monumentale wird, unabhängig ob spirituell oder weltlich, mit Macht und Status und mit Propaganda verknüpft. Durch das Verzerren des Formats untergräbt Mueck diese Assoziationen, es dient ihm als zusätzliches Mittel, den in seinen Figuren verkörperten Seelenzustand zu verstärken. Sein Koloss, der mit seinen Abmessungen einem Tempel oder Stadtplatz angemessen wäre, ist ein kauernder, barfüßiger kleiner Junge. Die ungewöhnliche

**10  Ghost** 1998
Mixed media
202 x 65 x 99 cm; 79$\frac{1}{2}$ x 25$\frac{1}{2}$ x 39 in.
Tate Gallery, Liverpool

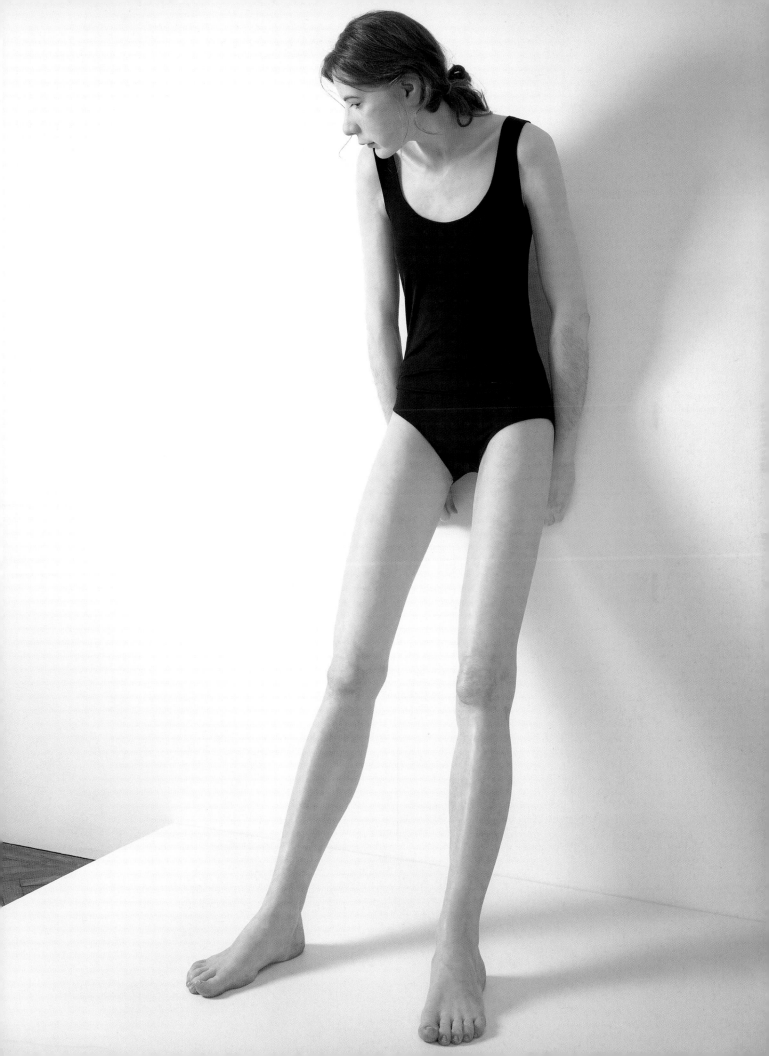

Dimensionierung soll den Betrachter zu einem unverbrauchten Blick zwingen. Wir müssen neu fokussieren, so als würden wir durch eine Linse schauen, weil das Format die Figur von ihrer Umgebung isoliert und unseren Blick ganz auf sie konzentriert. Gleichzeitig werden wir uns, indem wir unsere eigene Körpergröße mit der Figur vor unseren Augen vergleichen, des Raums, den unser Körper einnimmt, neu bewusst. Das Massige des *Big Man* wird durch seine Größe noch verstärkt, da er jedoch in einer Ecke hockt, überragen wir ihn im Stehen, und er scheint sich, in trübe Gedanken versunken, vor uns zurückzuziehen. Von einer Figur zur nächsten wandernd, nehmen wir unseren eigenen Körper mal als plump, mal als substanzlos wahr.

Muecks Methode, seine Figuren kleiner als lebensgroß zu machen, scheint ihnen eine konzentriertere, intensivere Präsenz zu geben: Ein winziges Baby kann eine ganze Galeriewand dominieren. In *Old Woman in Bed* schildert Mueck den Moment, der jenem in *Dead Dad* vorausgeht; die alte Frau scheint noch schwach durch den halb geöffneten Mund zu atmen. Eine verletzliche, schrumpfende Gestalt, man sieht, wie das Leben abnimmt, und doch ist ihre Hand der unbewegliche Fixpunkt des weißen Betts und des weißen Raums, der sie umgibt. Mueck wurde oft mit dem Satz zitiert, *Dead Dad* sei genau so groß, dass man ihn aufheben und in den Armen wiegen könnte. Das scheint weit entfernt von dem Impuls, den wir trotz unseres starken Mitgefühls vor diesem Werk verspüren. Obwohl wir jedes Detail in vergrößerter Deutlichkeit erkennen, wirkt die Figur unüberwindlich fern, scheint zu schwinden. Die Skulptur ist ein Abschiedsgruß, mit dem Mueck seinen Vater zur letzten Ruhe bettet. Anregung dazu war nicht, dass Mueck seinen toten Vater gesehen hat, sondern dass er ihn nicht gesehen hat: Er starb alles andere als friedlich auf der anderen Seite des Erdballs nach einer schweren Krankheit. Mueck beschreibt ihn als griesgrämigen, schwierigen Menschen, der im Leben des Sohnes nachhaltige Schatten geworfen hat. Im Tod legt der Künstler ihn still auf den Boden – gereinigt, klein, schweigend, friedlich. Und bei aller Zärtlichkeit hat man das Gefühl, dass Mueck sich die Kontrolle zurückerobert, indem er Leben und Tod des Vaters festhält und neutralisiert.

Dies ist eines der offenkundigeren Beispiele, wie stark Muecks Werk persönlich geprägt ist. Neben dem Vater hat er die todkranke Großmutter seiner Frau porträtiert und die Geburt seiner Kinder verarbeitet. In *Mask I*, seinem ersten Selbstporträt, stellt er sich vor, wie seine Kinder ihn sehen, wenn sie ausschimpft und sein grollendes Gesicht drohend über ihnen schwebt. In gewisser Hinsicht enthalten alle seine Werke Elemente eines Selbstporträts – ganz wörtlich, da Mueck oft Studien an

sich selbst betreibt, beispielsweise eine Socke abstreift, wenn er am Detail eines Fußes arbeitet, aber auch insofern, als seine Darstellungen von Seelenzuständen Entblößungen eines sehr zurückgezogenen Künstlers sind. Seine Figuren sind auf unterschiedliche Weise in ihrer Verletzlichkeit, Introvertiertheit oder Depression gefangen und scheinen unseren kritischen Blick nicht zu mögen. Kauernd, gekrümmt, in Fötalstellung oder unter Hüllen verborgen, entziehen sie sich unserem Blick, sodass wir uns vorbeugen und spähen müssen, um ihnen in die Augen zu sehen – nur um uns anschließend für unsere Neugier zu schämen. Muecks eigener Blick jedoch richtet sich schonungslos auf alles, was an seinen Modellen und an ihm selbst nicht perfekt ist. Wie wir gesehen haben, werden die expressiven Verzerrungen und Erfindungen von einer frappierenden Detailgenauigkeit begleitet, sodass Muecks Werk keine blanke Nachahmung der Wirklichkeit ist, sondern diese mittels eines minutiösen Perfektionismus beschwört. Ihre destillierte und konzentrierte Essenz entspricht wörtlich Bernard Berensons Definition von Kunst als »Leben mit höherem Wirklichkeitskoeffizienten«. Bei aller unendlichen Sorgfalt und Genauigkeit sorgt seine meisterhafte Beherrschung der Technik dafür, dass die Technik völlig verschwindet und wir vor dem menschlichen Körper als Faktum stehen. »So verbarg sein Können die Kunst«, wie Ovid von Pygmalion sagt.

## Anmerkungen

1 Charles Baudelaire, *Sämtliche Werke/Briefe,* Bd. 1, München 1977, S. 273.

2 Vgl. Ernst Kris und Otto Kurz, *Die Legende vom Künstler. Ein geschichtlicher Versuch,* Wien 1934, S. 69–86.

3 David Freedberg, *The Power of Images. Studies in the History and Theory of Response,* Chicago 1989.

4 Craig Raine, in: *Modern Painters,* Herbst 1998, S. 20–23.

5 Nigel Spivey, *Understanding Greek Sculpture. Ancient Meanings, Modern Readings,* New York 1996.

6 Hier ist vor allem Quatremère de Quincys Traktat über Polychromie in der antiken Bildhauerei zu nennen: *Le Jupiter olympien ou l'art de la sculpture antique consideré dans un nouveau point de vue,* Paris 1815.

7 Zitiert in Wolfgang Drost, »Colour, Sculpture, Mimesis. A Nineteenth-Century Debate«, in: *The Colour of Sculpture 1840–1910,* hrsg. von Andreas Bluhm, Zwolle 1996.

# Ron Mueck—A Redefinition of Realism    <span>SUSANNA GREEVES</span>

Visitors to the exhibition *Spellbound,* shown at the Hayward Gallery in 1996, were surprised to find the small figure of a young boy, naked but for a pair of white Y-fronts and a mischievous expression, standing in a room full of Paula Rego's giant canvases. Nothing in the gallery explained his presence, but the curious could find the story among the press clippings pinned up outside. Rego had asked her son-in-law, model maker Ron Mueck, to sit for her painting of Gepetto as he made his own *Pinocchio.* Mueck created not a puppet but a very real boy, who slipped unannounced into the art world under Rego's skirts. The fairytale parallel is beguiling. Gepetto, the master-craftsman, put aside his everyday work to pour all his skill into a figure made to fill a gap in his life. Mueck had enjoyed a successful career making models for film, television, and advertising but, feeling increasingly unfulfilled and frustrated by working to order, he had begun making work for his own private satisfaction.

Mueck's *Pinocchio* was also to change its maker's life after a fashion, turning him into a creator of "living" sculpture. Enter the familiar character of Charles Saatchi, fairy godfather to the Young British Artists. Intrigued by *Pinocchio,* he sought Mueck out, eventually acquiring *Big Babies, Angel,* and *Dead Dad.* This last became Mueck's first officially exhibited work, in *Sensation* at the Royal Academy 1997 (1998 at the Hamburger Bahnhof in Berlin) where it stole the show and catapulted Mueck into the first rank of the contemporary art world. The exhibition shown at the London National Gallery in the spring of 2003 and in the fall—again at the Hamburger Bahnhof—is a chance to look back at the artist's work to date, and an opportunity to consider it, albeit glancingly, in the light of other efforts through history to render the lifelike human figure.

Mueck has created the most flawlessly hyperreal figures in art history, so effectively imitating nature that the categories of art, image, and reality seem to be suspended. In the presence of a Mueck sculpture we are astonished by the perfection of the illusion: leaning in, it is impossible to fault, however close the range. Hairs sprout from pores, eyes glisten with moisture, flesh appears flushed or mottled. New developments in the history of art are often represented as technological advances driven by the pursuit of increased naturalism. Yet this impulse has been constantly checked by a deeply ingrained aversion to the too-lifelike, an uneasiness still present in our response to Mueck's work today. Historically, sculpture has been prized and denigrated for the same qualities—its directness, its power to move and to inspire empathy. The history of sculpture in Western civilization, then, is also the history of a debate over the very definitions and parameters of the terms "naturalism" and

**28  Pregnant Woman**  2002
Mixed media
252 x 73 x 68.9 cm;
99 1/4 x 28 3/4 x 27 1/8 in.
National Gallery of Australia, Canberra
Purchased with the assistance of Tony
and Carol Berg 2003

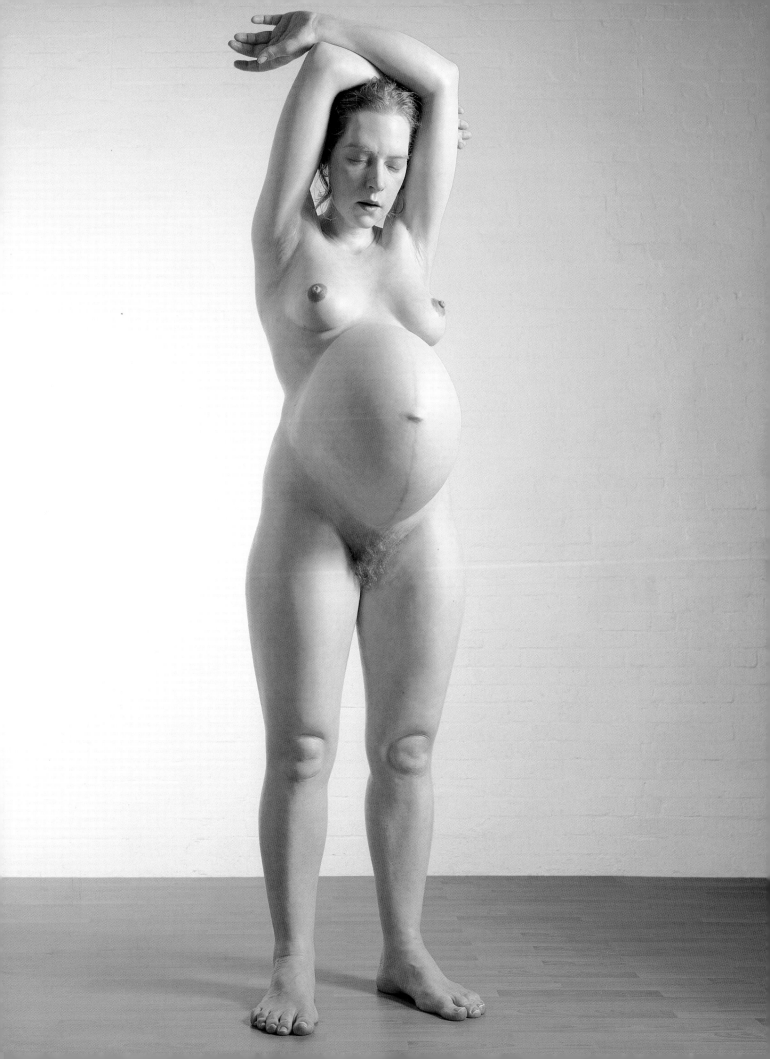

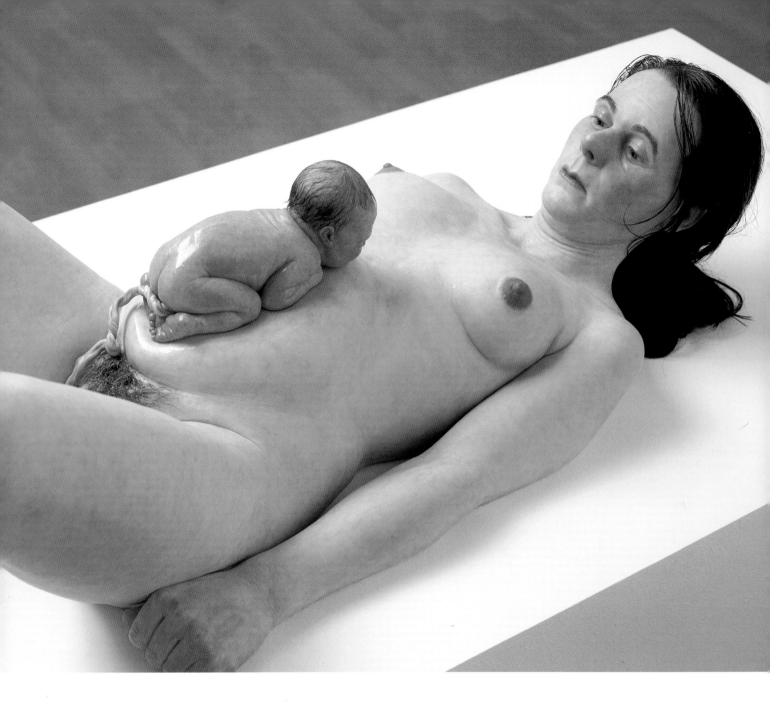

**23   Mother and Child**  2001
Mixed media
24 x 89 x 38 cm; 9½ x 35 x 15 in.
Collection Brandhorst, Germany

28

"realism." The pursuit of these qualities has produced the idealized bodies of the High-Renaissance period, when physical beauty was invested with moral or divine qualities, as well as the agonized, suffering body which medieval sculpture made an arena for Christian doctrine. "Realism" can be a truth to essential, universal nature or to detailed observation of a particular reality, an encapsulation of beauty or a repudiation of it. Mueck's hyper-realism is not "simply" the flawless technical imitation of reality, but requires another definition.

## Verisimilitude: Technique and Taboo

Confronting a work by Ron Mueck is an uncanny experience (and locking up a dark gallery full of them, alone, a downright eerie one). It is not that we actually think that they are alive, however, and there is not the momentary jolt of confusion that a sideways glimpse of a life-size dummy can deliver. Our experience of Mueck's illusion of life is more rewarding and prolonged because we are willing participants in the deception. In fact, our amazement is predicated on our awareness of deceit, and our pleasure lies in finding it out. We relish the contradictory messages of eyes and brain, the questioning of our senses. The overwhelming desire to touch that all viewers seem to feel is an urge to corroborate their eyes' impression of living warmth and softness. We indulge the fancy that as we turn away a feathered wing might stir, a held breath be released or an eyelid flicker, and we feel a genuine shiver of the uncanny. Despite our intellectual understanding of their man-made status, tension arises from the conflict between the material's inertia and its impression of liveliness; the fear of the lifelike which haunts the warring perceptions of the image as reflection, and the image as reality.

What lies behind the lifelike human figure's power to fascinate and to unsettle us? Another fairytale in which a man combines hands' skill and heart's longing to infuse a work of art with life, the story of Pygmalion and Galatea, is the founding myth of Western sculpture and paradigmatic act of creation. When the legendary King of Cyprus fell in love with the statue of a beautiful woman he had made, Venus brought her to life. The story describes the magical process through which a three-dimensional sculpted form can "become" a living, breathing entity. Similar tales are found in other mythologies, and stories of men's desire to create a living creature appear in many guises; among them the Jewish tradition of the Golem, Descartes's automaton Francine, and Frankenstein's monster. Each is an allegory of the rewards and risks inherent in the creative act—and more particularly an expression of our awareness that by creating a human figure we parody the act of divine creation. The

taboo that prohibits representation from approaching life too closely is deeply ingrained. Western traditions of aesthetics and philosophy are founded on Platonic theory, which deems exact representation both impossible and undesirable, and we are conditioned by centuries of polemic and prohibitions surrounding images.

The Pygmalion myth acknowledges the power of human responses to art, specifically to the three-dimensional human form. We well know that people are aroused by sculptures, pray and make pilgrimages to them, smash and topple them, are calmed or incited to revolt by them. The democracy and directness of sculpture's appeal, the strange seductive magnetism of its "thingness," have been the cause of intellectual suspicion and distaste, and have resulted in the negative value sometimes placed on verisimilitude. Charles Baudelaire identified a popular preference for sculpture's "unrefined immediacy" in an essay with the uncompromising title "Why Sculpture is Tiresome," and his is only one attack in a long historical debate that has largely favored painting over sculpture.[1]

A related prejudice, again stretching back to antiquity, is the belief in sight's supremacy over the other senses. Touch, the sense which Mueck's rendering of warm, heavy flesh or fine downy hair most arouses, has been deemed unreliable, dangerous, even morally questionable. At the same time, the oldest, clichéd compliment that can be paid a sculptor is to say that he can make marble seem flesh and blood, or make sculptures breathe or move. Daedalus, mythic progenitor of Greek art, was said to have made sculptures that walked off their bases—hyperbole taken so literally that statues have been excavated chained to their plinths at the ankle. Classical texts are full of admiring anecdotes of artists' ability to deceive—Zeuxis's painted grapes that were pecked by the birds, the calf which pined and starved beside Myron's sculpted cow—as well as statues' power to provoke emotion, and even violence and lust (the *Knidian Aphrodite,* the most impossibly beautiful representation of woman, was said to have a stain on her flank left by one particularly overwhelmed art lover). Similar formulae resurface in accounts of the master sculptors of the Renaissance, and seem not much more than mannered clichés when they appear in epigrams saluting Antonio Canova's "blushing marble."[2] It is sculpture in particular, of course, occupying our three-dimensional space, which can fool us into responding as if to the real.

Mueck's works render flesh, blood, hair, substance, and texture with breathtaking accuracy. What else do we look for to test for signs of life? Movement is perhaps the first signifier. Mueck's sculptures are still, but not frozen mid-gesture: in attitudes of rest, they retain the possibility of motion. We also look to the eyes—which is

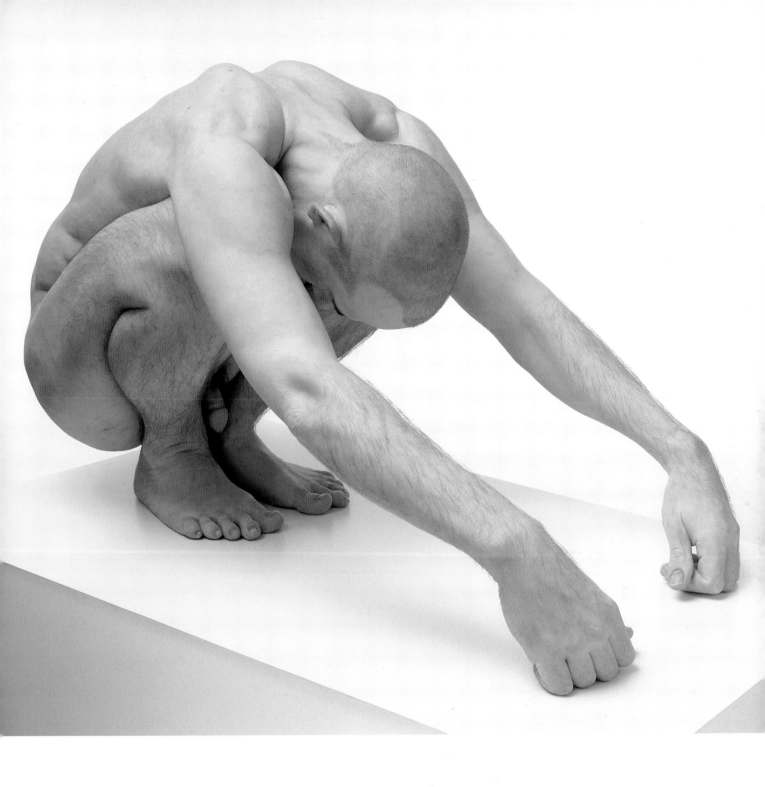

why it is so disturbing to see an image, or indeed a person, without them. There is a Chinese tradition that the painter does not complete the eyes of his subjects, in order to prevent them escaping his control.[3] Mueck lavishes extraordinary care on hand-making his models' eyes in many stages, building up a transparent lens over a colored iris and deep, black pupil. When he finally inserts them the effect is startling, as the figure appears to come to life. A waxwork's vacant, glassy stare quickly betrays lifelessness. Not only are Mueck's eyes astonishingly real, but they may

**12 Shaved Head** 1998
Mixed media
49.5 x 36.7 x 83.8 cm;
19½ x 17¼ x 33 in.
Sammlung Hoffmann, Berlin

31

glint from half-closed lids, be partly concealed, or cast reflectively downwards: our sense of a life behind the eyes persists.

*Dead Dad*'s eyes are closed. His thick gray hair has been brushed back from the lined face, now slackened into melancholy repose. This is the one sculpture in which Mueck convinces us not of the presence, but of the absence of life. Although we know better, we experience the chilling sensation that we are looking not at a representation but at the thing itself, a corpse. The body is real to us in every fleshy detail, but somehow we know that life—once present—has now departed. *Dead Dad* encapsulates one of the crucial questions at the heart of Mueck's work: what distinguishes animate and inanimate matter; what is the essence that animates, the spark that constitutes life? As Craig Raine has written, "Ron Mueck's sculpture explains why man has felt the need to invent the idea of the soul."[4]

## From the *Kritian Boy* to *Mueck's Boy*

One figure stands at the origin of the history of naturalism in sculpture, a distant ancestor in whatever erratic lineage we might trace to Mueck. Dubbed "cover boy of the Greek revolution," the *Kritian Boy* represents the end of a stiff and stylized sculptural tradition and signals the movement towards an accurate imitation of nature, one of Western art's most profound developments.[5] Two key factors in this revolution were technological innovation—the invention of techniques that would allow greater detail—and the drive of narrative, the desire to involve viewers through convincing emotion and drama in order to better tell a story. Here are the basic impulses which have held true down to Mueck: refining techniques to create a closer imitation of reality, and so convey a convincing psychological presence. However, the newly naturalistic figures of the classical period were athletes, heroes, gods. They represented an ideal, achieved by blending the human and divine, the universal and the specific. These classical principles were later codified by the Renaissance into mathematical rules governing proportion and anatomy, perspective and foreshortening, composition and symmetry. One of the most familiar images of the Renaissance, Leonardo da Vinci's (1452–1519) *Vitruvian Man*, perfectly demonstrates their lasting influence on Western aesthetics.

Mueck's work seems so scrupulously faithful to reality in the detail that one does not immediately notice the larger liberties he takes with precisely these principles of proportion and anatomy. Although he uses life models, *Boy*, *Big Man*, and *Shaved Head* are all in poses Mueck's sitters found impossible. Their bodies are folded into more compact forms than we can easily achieve, yet each one seems relaxed,

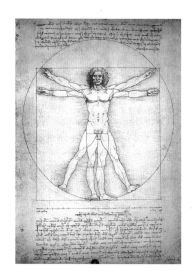

LEONARDO DA VINCI
*Vitruvian Man*, 1509
Pen-and-ink drawing with watercolors
34.4 x 24.5 cm; 13$^{1}$/$_{2}$ x 9$^{5}$/$_{8}$ in.
Galleria dell'Accademia, Venice

absolutely balanced and stable, solidly rooted to the ground. Out of the knot of his body, the figure in *Shaved Head* drapes long arms and huge, heavy hands, knuckles weighted to the ground in front of him. Mentally unfolding him to standing height, we can see how disproportionate they would seem to his frame (here is an echo of Michelangelo's [1475–1564] *David,* whose enormous hand rests gracefully against his thigh). He has the latent energy and grace of an athlete or dancer, seeming simultaneously coiled and at rest, his furled body balanced against the droop of his arms. *Big Man's* dense, solid bulk is packed into a corner, a fleshy manifestation of misery. Perversely, these expressive distortions invest Mueck's figures with the living charge that an actual life-cast lacks: though it may be a perfect and exact reproduction of a living body, a cast will always seem a stiff, dead shell. Mueck works from life, from found images and anatomical source books, but he does not apply any methods of calculation. His sculptures can spend weeks and months as clay while he gropes towards a sense of proportional "rightness" for the figure that is not based on fidelity to a living model, but is particular to the figure he is creating.

Mueck's figures are also far from perfect or ideal: they are awkward, flawed, mortal flesh. His reality has the shocking honesty of the Gothic, an unflinching observation of the body naked, rather than nude. Certainly Jan Van Eyck's (about 1390–1441) *Adam and Eve* appear stark naked. These are real people, minutely observed and reproduced with dispassionate accuracy. There is none of the idealizing influence of classical Greece which Van Eyck's Italian contemporaries never quite lost. Van Eyck was a technical innovator, developing the new medium of oil glaze to reproduce reality in finer, more glowing detail. His array of visual effects of texture and surface is dazzling: wisps of hair, stiff brocade, hand-blown glass and polished pewter are rendered with an almost unnatural clarity. This is a reality constructed through the build-up of crystalline observed detail rather than a masterly adherence to the many scientific laws of the Renaissance. In the same manner Mueck assembles an exhaustive itemization of the body, from a callused heel to a ridged fingernail or the shadowed hollow of a throat. There is a shared sensibility in Mueck's figures and in the hard, brilliant clarity of the Northern revolution in realism. Compare his *Seated Woman* with the portrait attributed to Albrecht Dürer (1471–1528) of his father at seventy or *Dead Dad* with Holbein's (1497–1543) devastating image of *The Body of the Dead Christ in the Tomb,* glassy-eyed, his hand a stiff claw.

A neat binary system was established by the Renaissance, Gothic North on the one hand and Graeco-Roman South on the other, excluding the Iberian Peninsula alto-

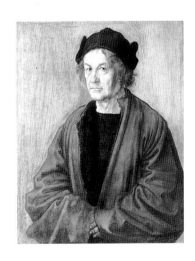

Attributed to ALBRECHT DÜRER
*The Painter's Father,* 1497
Oil on linen
51 x 40.3 cm; 20¹⁄₈ x 15⁷⁄₈ in.
The National Gallery, London

33

gether. But the art which flourished there from the fifteenth century onwards, ignored or dismissed by the rest of Europe, positively embraced the unsettling power of the hyper-real. The Spanish polychrome tradition saw painters and sculptors collaborating to produce figures of extreme naturalism, carved in wood before being coated in gesso, a primer, smoothed and painted, and finished with glass eyes, ivory teeth, real hair, clothing, and jewels. Gregorio Fernandez (1576–1636), the seventeenth-century master of the Valladolid school, muted the gaudy colors and restrained the exaggerated gesture of his predecessors. His *Ecce Homo* simply asks the viewer to behold Christ as man, confronting us with a life-size figure, seemingly of flesh and blood. The apogee of the tradition is represented by the refined and sensitive modeling and meticulously accurate detail of Fernandez and his near contemporary Juan Martinez Montañes (1568–1649). Their technique of painting the flesh was perfected to convey palpitating veins and muscles tense or slack beneath the skin, detailing every minute accident of surface and substance. The intention was to create figures with the greatest possible physical, sensual presence, of the most convincing reality, as if actors within a narrative drama. The Virgin, for example, was more likely to be portrayed as a distraught middle-aged woman than a classical Venus with child. By deliberately breaking down the borders between art and reality, and so the separation of the figure from the viewer, they meant to communicate, emotionally and viscerally, a religious message. Rejecting idealized aesthetics, their aim was to embody real human emotion and suffering, and the artist's success was measured in the tears and ecstasies of the viewer. The effect was intended not only for the simple and credulous; patrons and connoisseurs wrote admiringly of being hypnotized, transported or overwhelmed.

The pitch of emotion and religious fervor may seem very foreign, but the shocking reality and directness of these sculptures bear an obvious relation to Mueck's work. The Spanish sculptors use our connection with their "real" people to suggest universal (religious) truths. Mueck's figures are intensely personal, particular representations but they seem to function in the same way, connecting us to universal emotions and experiences. The experience of this lapse between the reality of the art object and reality itself demands a response that integrates emotion and cognition. That is to say, Mueck's works commonly provoke a response to the subject itself, the person represented, and elicit memories of our own emotions and experiences, mundane and profound: childhood, childbirth, and parenthood, the aging and death of a parent. It is not a form of response which the contemporary language of formalist criticism is equipped to deal with, though it is as valid to our understanding of

**13 Seated Woman** 1999
Mixed media
Figure: 58 x 28 x 39 cm;
22 7/8 x 11 x 15 3/8 in.
Overall: 75 x 62 x 56 cm;
29 1/2 x 24 3/8 x 22 in.
Ed. 1/1
Museum of Modern Art, Fort Worth

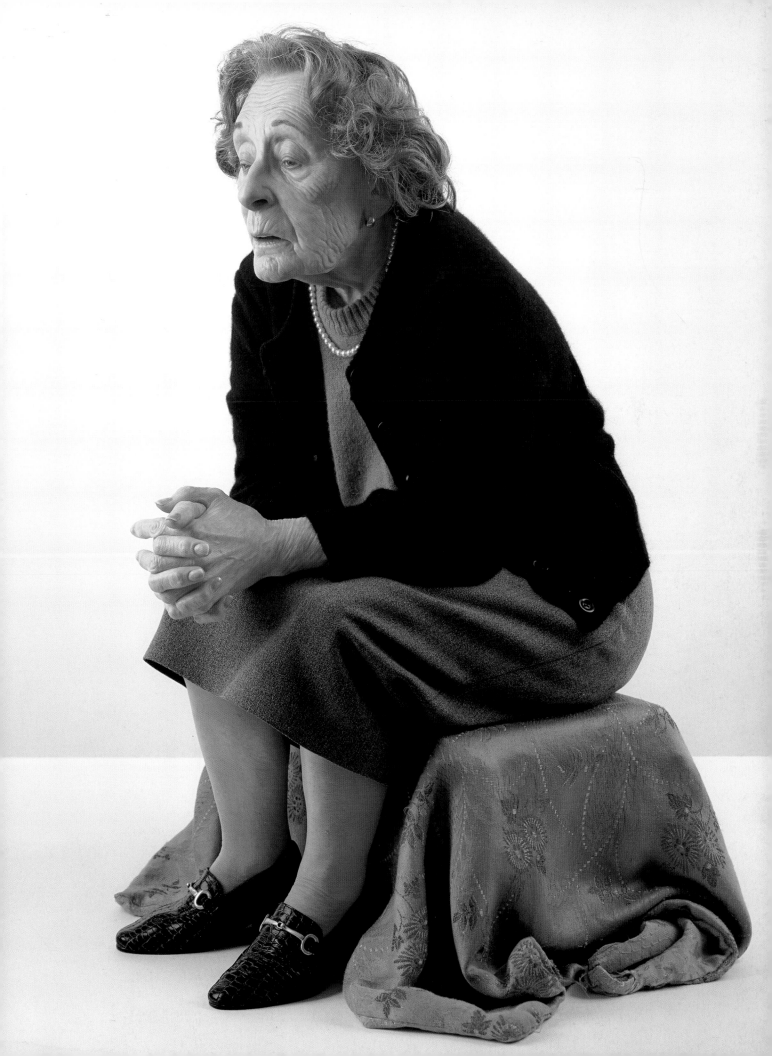

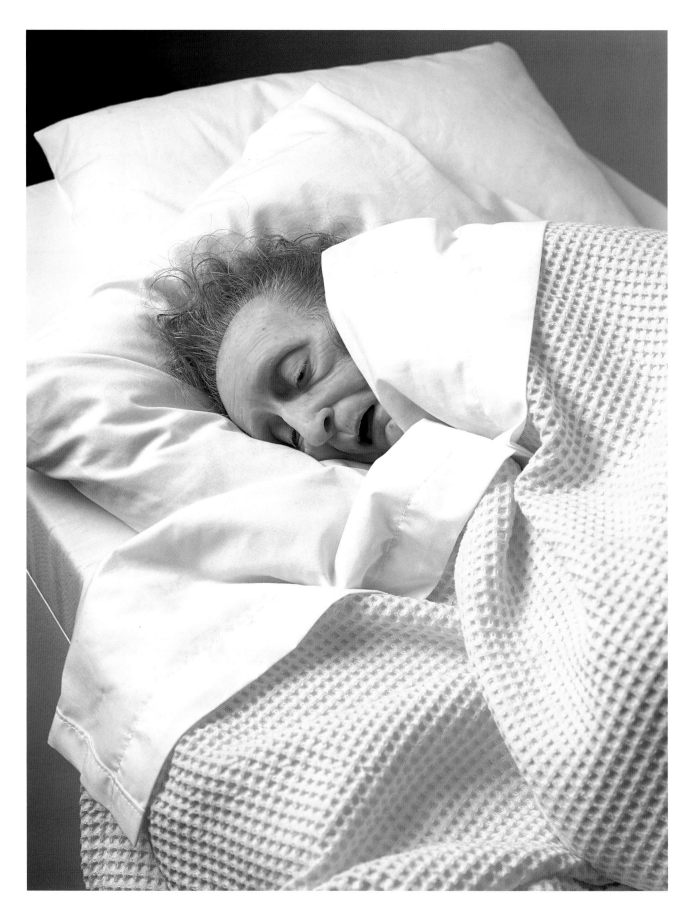

Mueck's works as any informed perception of art historical resonances. Sculpture that imitates reality has historically been suspect on the grounds that it is likely to provoke a baser response, working on an emotional or physical level rather than a refined intellectual one. It is a distinction that sometimes still seems to be operating, as betrayed by a critical suspicion of work with popular, accessible appeal.

The perceived distinction between "high" and "low" became increasingly exaggerated in the eighteenth century. The craze for excavating, studying and collecting classical sculpture grew, the dazzling whiteness of its unearthed state enforcing its status as the sublime, philosophically pure ideal. At the same time, dolls, dummies, automata, and waxworks were increasingly popular entertainments, so that all life-like treatments of the body became associated with these "low" or "debased" forms. However, by the end of the century the increasing weight of evidence finally forced a major reassessment of the antique.[6] Rather than being the model and embodiment of eighteenth-century moralized aesthetics, it was discovered that Greek sculpture had been brightly painted and ornamented, with wire eyelashes and tinted lips and nipples. Now we know that even the *Kritian Boy* had once had inlaid eyes, and probably—like the Parthenon—an organic wash toning down the bare marble. Ironically, having provided the inspiration for the pure marble body of neoclassicism, the ancient world was to provoke the nineteenth century into a range of experiments in painted, tinted and mixed media sculpture.

Nevertheless, when Edgar Degas (1834–1917) first exhibited his *Little Dancer of Fourteen Years* in 1881, his contemporary audience found the work deeply shocking. Modeled in wax and tinted rosily, she was dressed in a fabric tutu and bodice, stockings and slippers, with a wig of real hair tied back in a green ribbon (the bronze casts we are now familiar with were not made until 1921). These materials associated her with carnival and the grotesque, with scientific study, and with the newly rediscovered Spanish Catholic tradition, while her brutish features and assumed immorality horrified contemporary viewers. One observed that she "belonged in a zoological, anthropological, or medical museum." The critic J. K. Huysmans diagnosed his own sense of revulsion: "the terrible reality of this statuette makes one distinctly uneasy; all one's ideas about sculpture, about these inanimate whitenesses, about these memorable clichés copied down the centuries, all are overturned." His final verdict was that this was "the first truly modern sculpture."[7] Rather than an attempt to portray an ideal or generalized humanity, she is, like Mueck's figures, a very particular, individual, and unromanticized type, her personality proclaimed by the pert jut of her chin.

**25 Old Woman in Bed**  2000/2002
Mixed media
24 x 94.5 x 56 cm; 9 ½ x 37 ¼ x 22 in.
A/P
Art Gallery of New South Wales –
Purchased 2003

In common with the *Little Dancer* and the Spanish saints, Mueck's figures have real clothes and hair. In fact, *Dead Dad*'s legs are prickled with the artist's own hair (a practice which he has not been able to sustain for obvious reasons). Though entirely practical, this detail lends the work a powerful aura of reliquary or votive representations of the dead. Since Mueck is extremely sparing in his choice of garments or props, each seems rich with significance. Some are invented and made to scale, but often they are found and bear signs of wear and use. The cocoon surrounding *Man in Blankets* is of clean but worn institutional woolen blankets, their charcoal gray shadowing the depths of his nest, the blue and pink of the outer layers picking out his faint flush and bluish veins. These props are mysterious details, potential clues to a narrative not spelled out to us—but others have immediate clear resonances. *Old Woman in Bed* is folded between crisp sheets which clearly signify a hospital or nursing home. *Seated Woman* has a new woolen twinset and pearls, but the gold-buckled, crocodile shoes bulging over painful corns and her neat gold earrings, Mueck made for her. She sits on a worn and faded piece of brocade which manages to conjure an environment of overstuffed sofas and tables crowded with knickknacks, and perhaps future generations who will be reminded of her by this piece of cloth.

## A New Kind of Realism

Realism today often means real objects, or a concentration on real and verifiable concrete qualities, as in minimalism: that is, an existentialist realism rather than an illusionist, counterfeit realism. Even the hyper-real descriptive art of the last few decades is driven by impersonal observation and an unsparing factuality. But Mueck does not merely create the most flawless illusion of reality yet achieved: he restores subjectivity and humanism to the hyper-real. In his minute, unflinching itemization of real, imperfect human bodies Mueck also manages to convey an internal narrative, in a powerful evocation of what we might term psychological realism. Psychology is, after all, the essential new informant of our contemporary readings, replacing political, mythical, or religious constructs. These sculptures are portraits of emotional states, and after our initial astonishment at their verisimilitude it is their impression of an inner life that holds our continued attention. *Ghost* is the embodiment of teenage self-consciousness, the projection of a stage at which our bodies become suddenly large and strange and acutely embarrassing to us. Two meters tall, rawboned, slightly pimply, she hunches against the wall as if wishing her regulation swimsuit could conceal her. *Seated Woman* is a portrait of dignified aging, the precise pitch of life-weariness studied as finely as the web of lines netting her translu-

cent fingers. She looks resigned, but not defeated, as she holds her head cocked slightly against the droop of her eyelids and neck.

Scale is one of the most powerful tools Mueck employs with this psychological intent. Though they appear to be made of the same living stuff as us, his sculptures are not of our world. Not human size, and certainly not giants or midgets, they are removed to their own dimension by differences of scale. There are clear historical associations attached to extremes of size in sculpture. Small objects are precious, and often for private enjoyment and handling. The monumental is associated with power and status, spiritual or temporal, and so also with propaganda. Mueck completely subverts these associations in his distortions of scale, and instead employs it as another means of intensifying the emotional states his figures embody. His colossus, whose size would be appropriate to a temple or city square, is a young, crouching, barefoot boy. Shifts in scale are also a means to force the viewer into a fresh way of seeing. We have to re-focus, as if looking through a lens, as the scale isolates the figure from its surroundings and concentrates our gaze. At the same time we are made freshly aware of the space our own body occupies, measuring ourselves against what we see. *Big Man*'s already threatening bulk is obviously magnified still further by his scale, but as he hunkers in the corner we stand taller than him and he retreats from us in his introspective unhappiness. Moving from figure to figure, our sense of our physical selves lurches from feeling clumsy to insubstantial.

Making figures smaller than life-size seems to concentrate and intensify their presence: a tiny baby can dominate an entire wall of a gallery. In *Old Woman in Bed*, Mueck addresses the moment before that we see in *Dead Dad*, in which her breath still seems to labor through her half-open mouth. She is a vulnerable figure, shrinking as her life ebbs, yet her head is the still, compelling focal point of the white bed and larger white space which surround her. Mueck has been much quoted as saying that *Dead Dad*'s size is such that one could pick him up and cradle him. In fact this seems very far from the impulse we actually feel in front of it, despite our overwhelming empathy. Although we can see every detail in magnified clarity, the small figure seems permanently distant, dwindling. The sculpture is a farewell and a laying to rest. It was inspired not by Mueck seeing his dead father, but by not seeing him: he died less than peacefully on the other side of the world after a painful illness. Mueck describes him as a morose and difficult man who loomed large in his son's life. In death, the artist lays him out, scrubbed, small, silent, peaceful—and beside enormous tenderness there is a sense that Mueck is taking back control, containing and neutralizing the realities of his father's life and death.

This is one of the more obvious examples of the intensely personal nature of Mueck's work. As well as his father, he has portrayed his wife's grandmother in her final illness, and drawn on his experiences of his children's births. *Mask*, his first self portrait, was inspired by his imagining how his small daughters saw him as he scolded them, his scowling face looming above. In a way, each one of the artist's works contains an element of self-portraiture—quite literally, as Mueck will often use himself as a convenient reference, stripping off a sock while finishing the detail on a foot for example—but also in that these portraits of emotional states are acts of exposure by an intensely private and reclusive artist. His figures seem trapped in various states of vulnerability, introversion or depression, and appear to resent our scrutiny. Crouching, huddled, in a fetal position or concealing themselves under wraps, they evade our gaze so that we stoop and peer and pry to meet their eyes, then feel ashamed of the intrusion. Mueck's gaze, however, is unflinchingly turned on every imperfection of his subjects and himself. Astonishing accuracy of detail accompanies expressive distortions and inventions, as we have seen, so that what Mueck creates is not a blank imitation but an invocation of reality, summoned out of this minute perfectionism. Its distilled and concentrated essence fits in a very literal way Bernard Berenson's definition of art as "life with a higher coefficient of reality." Though infinitely painstaking and laborious, his absolute technical mastery is such that the technique disappears altogether, leaving us with the fact of the body itself. "His art conceals its art," as Ovid says of his Pygmalion.

**Notes**

1 Charles Baudelaire's address to the Académie Française, Salon of 1846 in Joseph Mashek, "Verist Sculpture," *Art in America* 60, no. 6, (1972), in Gregory Battcock, ed., *Super Realism: A Critical Anthology* (New York, 1975).

2 Ernst Kris and Otto Kurz, *Legend, Myth and Magic in the Image of the Artist* (New Haven, 1979).

3 David Freedberg, *The Power of Images: Studies in the History and Theory of Response* (Chicago, 1989).

4 Craig Raine, *Modern Painters* (autumn 1998), pp. 20–23.

5 Nigel Spivey, *Understanding Greek Sculpture: Ancient Meanings, Modern Readings* (New York, 1996).

6 Specifically Quatremere de Quincy's findings of his 1815 treatise on polychromy in ancient sculpture.

7 Cited in Wolfgang Drost, "Colour, Sculpture, Mimesis: A Nineteenth-Century Debate," in Andreas Bluhm, ed., *The Colour of Sculpture 1840–1910* (Zwolle, 1996).

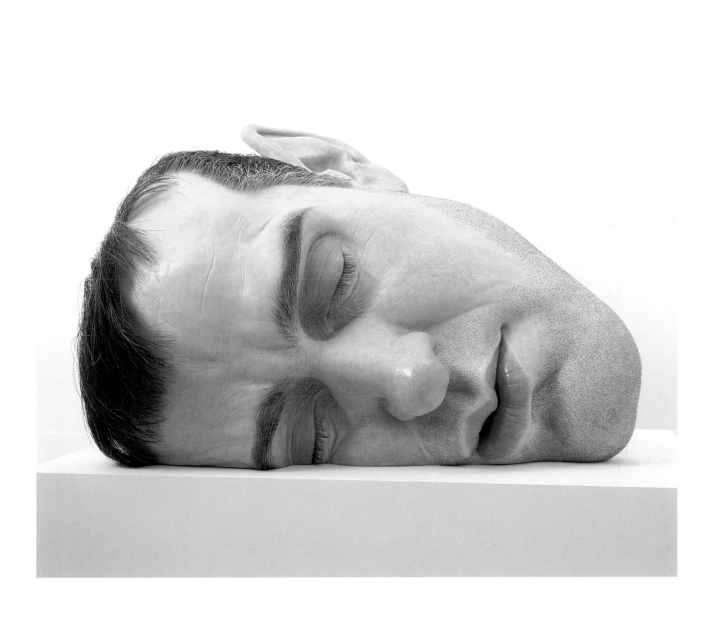

**24　Mask II**　2001
Mixed media
77 x 118 x 85 cm; 30⅜ x 46½ x 33½ in.
Ed. 1/1
Art Supporting Foundation / SF MoMA

# Bemerkungen über einige Skulpturen von Ron Mueck <span style="float:right">HEINER BASTIAN</span>

*»Unter dem dunkel surrenden Flügelschlagen des Vogels Greif erträumten wir –*
*zwischen Ergreifung und Ergriffenheit – den Begriff vom Bewusstsein.«*

<div style="text-align:right">ABY WARBURG</div>

Die verborgene, unleugbar enigmatische Gestalt, fast ganz eingehüllt in ein weißes
Tuch, blickt ins Innere ihrer Seele. Wohin sonst sollte sie sehen? In der Einsamkeit,
der wir begegnen, der fehlenden Blickbeziehung zu den überwachen Augen, aber
vor allem in der passiven, beinahe demütig meditativen Körperhaltung rückt die
Gestalt der Nähe in eine unbestimmte Ferne. In diesem Dualismus von nah und
unnahbar, Stille und Sagbarem sind Ron Muecks Skulpturen vielleicht zu sehen.
Ihre Referenzen sind keineswegs historisch; eher sind diese wohl analoge Projektio-
nen einer sehr zeitgenössischen Wahrnehmung des Künstlers. Und dennoch: Die
Fragen zu dieser Art »menschlichen Bildermachens« sind vielfach psychopatholo-
gischer Natur, die nicht mehr als einen synthetischen Sinn ergeben.

Die verborgene Gestalt *Man in a Sheet* reflektiert einen Seelenzustand, der die
Schattenseiten der Vita contemplativa nicht leugnet. *Allein* heißt eine dieser For-
meln, *Inversion* eine andere: *Allein* im Bild der Nahsicht auf das eigene Verloren-
sein, *Inversion* im Bild allegorischer Präsenz. Denn wir wissen nicht, ob diese
äußerst reduzierte Darstellung eines Mannes zwischen innerem Monolog oder
Agonie überhaupt unterscheiden will oder in der Überzeichnung von Defizienz die
geheimnisvolle Wirkung eines Vexierbildes sucht. Aber was ist dieses Vexierbild?
Eine Wirklichkeit, die hinter die Vorstellung von Wirklichkeit zurücktritt? Weil die
Skulptur nicht deskriptiv ist, gehört der Augenblick der Aneignung, der Moment
der Betroffenheit zu ihrer Präsenz, zu ihrer Behauptung. Über unsere Wahrneh-
mung sagt dieses vor einigen Jahren entstandene Werk: Die Welt ist imaginär.

Wie eingenommen sind wir von dieser Art poetischem Archetypus, in dem eine
stille, fast unsichtbare Skulptur eher auf das nicht Sagbare zeigt, das Abwesende.
Der unter dem Leinen kauernde Mann, von dem wir nur das Gesicht sehen –
zurückgezogen, wie in einer letzten Hülle –, evoziert eine Lebensspur. Es ist der
Widerschein einer Erscheinung von Abgeschiedenheit, die zur Temporalität dieser
Lebensspur wird. Unterscheiden können wir nicht, wie viel hier von Wollen und
Erkennen, von Fügung und inneren, bestätigten Beschlüssen mitgedacht ist. Im
Ausdruck des Gesichts verwischen sich alle Spuren in die Vorzeichnung eines Leer-
raums, in die Distanz einer Vorahnung. Darum ist Leben eine der fragilen Behaup-
tungen dieser Skulptur und das Verweisen und die Erwartung eine starke Kraft. Es
bleibt jedoch unentschieden, ob diese Energie einer gesteigerten Betroffenheit

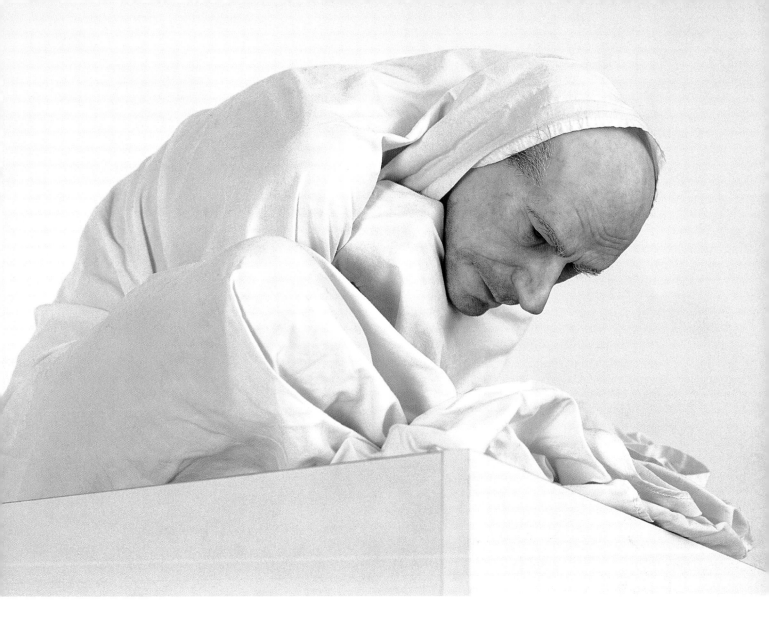

»anwesend« ist oder als epiphanischer Augenblick gedacht werden kann. Und je mehr wir uns in diese Skulptur einsehen, je mehr sie auf uns einwirkt, umso stärker wird die Gegenwart affektiver Präsenz und der Absenz von etwas, das wir nicht beantworten können. *Ins Rätselhafte* heißt eine weitere Formel im Werk dieses Künstlers. Es ist diese Repräsentationspraktik, die die Herrschaft des inneren Monologs der Skulptur als fortwährende Behauptung bricht und den Blick des Betrachters als Echo erfordert.

Der Verismus der Werke Ron Muecks wandelt sich. Er wandelt sich durch uns. Und darum ist sein Realismus eher das Reich des Realisierens, eine temporale Eigenschaft. Denn weniger die stets festgehaltene, bewunderte und vielfach beschriebene hyperfaktische Genauigkeit der Darstellung ist es, die Ron Muecks Arbeiten auszeichnet, nicht deren ungeheure Lebensnähe, sondern das glaubwürdige existenzielle Aufscheinen von Lebensumständen. Eine Art Gravitation von Existenz zeigt sich hier ohne moralische Belehrung.

**9  Man in a Sheet**  1997
Mixed media
34 x 48.5 x 50 cm;
13³/₈ x 19¹/₈ x 19³/₄ in.
Sammlung Olbricht

Die Rückgewinnung einer Identität (der Identität des Kunstwerks) aus dem kaum zu übertreffenden, dinglichen Realismus gehört ebenfalls zu den Grundvoraussetzungen dieses Künstlers. Wie kann man einem toten Körper wie in einem Filmstill den Ausdruck von Leben verleihen? Erst aus dieser Vorstellung einer momentanen Chiffre von Leben entsteht die Beunruhigung des Betrachters, indem er das Selbst der Darstellung auch als das Lebendige empfinden kann. Das Lebendige ist die Beredsamkeit der Figur, ihre Kraft, die sie aus einem reinen Abbild ins Fremde versetzt. Dass in den Werken Ron Muecks dieser Aspekt zum Charisma seiner Figuren gehört, dass das Fremde auch Anspruch auf das Enigmatische hat, ist oft genug hervorgehoben worden. Das eigentlich Unbelebte verkehrt sich in der Wendung zur Identität ins »glaubhaft« Physiologische. Die Betrachtung schwankt zwischen dem schier greifbaren, unbeseelten Körper und der Wirkung, die aus dem psychologischen Bedürfnis den Sog des Lebens vergegenwärtigen, geltend machen will.

Unsere Empfindung wird nicht geleitet von der ikonischen Indifferenz der insistierenden Rätselhaftigkeit, sondern eher von der Vertiefung eines Schattens, den wir als das nicht Sagbare behaupten und manchmal als Schmerz empfinden. In allen Skulpturen dieses Künstlers finden wir diese eine Vision: dass hinter der rationalen Wahrnehmung die Imagination eine parallele Welt ist. Nicht das Leben will sich hier verflüchtigen, sondern beharrlich aus unbeseelter Materie sprechen.

Ron Muecks Skulptur *Man in a Sheet*, die hier keinesfalls exemplarisch oder gar kodifiziert betrachtet werden soll, ist in ihrer Erscheinung oder Geste eine Ausdrucksform, die wir in anderen Werken als differenzierte Aussage wieder finden. Jede Geste, auch wenn wir sie nur intuitiv auffassen, verwandelt sich in einen symbolischen Ausdruck. Diese Kongruenzen lesen wir im Verweisen auf die Vereinzelung des Menschen, und wir deuten sie in beinahe jeder Form des fehlenden Rückbezugs auf den Kontext der Alltagswelt. Alle Ereignisse und Umstände des Handelns, die Anwesenheit von Symbolik und Mythos sind ausgespart. Die mimetische Körpersprache assoziiert in Muecks Darstellungen Bilder des Alleinseins und des Geworfenseins. Verstehen wir dieses Alleinsein als selbst gewählte Haltung, dann müssen wir diese spezifische Prägung auch als Trauer und Melancholie, als zweifelnde Kontemplation erkennen. Die Entfremdung und eine Art Bodenlosigkeit als gestörtes Verhältnis des Einzelnen zu der ihn umgebenden Kultur, ebenso die Antizipation der Absurdität einer nur noch fragmentarisch zu erfassenden, dadurch fremden Welt gehören zu den unübersehbaren Zeichen dieses Werks.

Wenn ich von Absurdität spreche, meine ich sie hier als Unabänderlichkeit, die sich nur als kontradiktorische Passion in der Realität einrichtet – ohne jede Verklärung.

In der Skulptur *Shaved Head,* einer kauernden unbekleideten Figur, die nichts zur Schau stellt, begegnet uns eine Physiognomie, die dem Bildnis *Man in a Sheet* ähnlich ist. Beinahe zwanghaft die extreme Pose, scheinbar irreversibel die Situation. Aus dem Fluss allen Geschehens, aus dem Strom der Zeit, das ist der erste aller Gedanken beim Anblick dieser Darstellung. Die Hermetik aus Zurückgezogenheit, der unsichtbare, auf dem Boden haftende Blick, der dem gebeugten Leib jede Mimik entzieht, sind die einzigen Zeichen der Auflösung. Auch die Stille, die nur die Stille des Autismus sein kann, das Halluzinatorische, Echolose der verwunschenen Körperhaltung sprechen von Verstörung. Hier zeigen sich Affinitäten einer Gebanntheit, wie wir sie aus dem Werk Edvard Munchs kennen: das Geraune psychischer Anfechtungen, die nie den »Sturz« meinen, sondern die Initiation, das Aufkommen, die Vorahnung. Letztlich sehen wir hier die Einbildungskraft für Bilder der Nacht!

Ganz anders jedoch der vorsichtige, die Erstarrung des Augenblicks auflösende Optimismus beim Blick auf die Skulptur *Man in a Boat.* Das deskriptive, unbewegliche Maß melancholischer Gegenwart, das viele der Skulpturen Ron Muecks umgibt, trifft sich in diesem Werk an einem imaginären Horizont. Alles Angehaltene, alles Stillgestellte, die Introvertiertheit der Figur gerät in erzählerische Bewegung. Der Mann im Boot, eine unbekleidete, sehr kleine Figur, die ihre eigene Welt der Wahrnehmung als Fahrt in einem Boot durch unsere »Wirklichkeit der Welt« erprobt – so oder so ähnlich sehen wir den Fahrenden gebannt von der irritierenden Magie der Illusion. Der Mann im Boot »spricht« davon, was ihn voller skeptischer Ahnung in imaginärer Ferne erwartet. Seine Augen sprechen von der Gefasstheit, dem Lidschlag unabänderlicher Bande und Gleichungen. Mag sein, dass dieses Boot als Metapher der Determiniertheit unseres »Fahrens« gemeint ist. Dann wäre es stumm, und die Anwesenheit des Fahrenden wäre von der gleichen psychischen Ambiguität aller Figuren dieses Künstlers: hin- und hergeworfen zwischen Melancholie und Erschrecken, Märchen und sibyllinischer Welt. Vielleicht aber heißt Fahren hier Heraustreten, und der Monolog des Mannes im Boot ist ein Gespräch, ist Entdeckung. Und sind diese Figuren des Künstlers nicht auch im Vorhinein Bilder eines unbekannten, jedoch gescheiterten Pyrrhon des 21. Jahrhunderts?

In dieser taktilen Beziehung zur Wirklichkeit finden Muecks Arbeiten ihre elementare, eine äußerst reduzierte Luzidität. Untrennbar verbindet sich die archaische Darstellung mit der außergewöhnlichen Ausdruckskraft psychischer Eigenschaften: So wird der Mann im Boot in seiner kindlich widersprüchlichen Körpergröße und dem Ausdruck des Erwachsenen, noch einmal, jenseits des symbolischen Bildes der Einsamkeit, auf unvertraute Weise schmerzlich, verurteilt zum Alleinsein.

Alles in diesem Werk scheint subtil, gar zögerlich, das unsichtbare Bild zu evozieren, dass hinter dem Verismus das Andere, das Verborgene ist, vielleicht sogar das Unauffindbare. Nirgendwo zeigt sich der Behauptungswille einer Innovation oder der Blick auf das nur Machbare. Das Alleinsein des Mannes im Boot ist darum auch der Augenblick der Unermesslichkeit und der Chimären. Die Frage nach dem, was der Mann sieht, bleibt offen, ist ganz und gar explizit, und es ist dennoch nur das Echo seiner eigenen Vorstellungskraft. Eine dieser Projektionen der Vorstellung ist der Raum, der angesichts der rigorosen Intensität körperlicher Relativität zur übergroßen, bedeutungsvollen Ausdehnung wird. Bei der Betrachtung geraten wir darum auch selbst in diesen Raum, der gar nicht komplementär gedacht, sondern bewusst inszeniert ist: reine Welt der Anspielungen.

Dieses Zwiegespräch mit dem Raum ist also nicht die Sehnsucht nach einem wirklichen Raum, sondern der Monolog von einer Vorstellung des Raums, der sich verflüchtigt, der von der Skulptur emaniert und wieder aufgesogen wird. Wenn wir das Werk Ron Muecks befragen, müssen wir darum seine Stille befragen, denn der Raum, der das Werk umgibt, ist nicht der Raum des Lichts und der Schatten, des Echos und der Resonanz, sondern der namenlose Raum der Fiktion. Er verweist uns zurück auf die Figur und deren Proportion, auf Gestik und Mimik und deren Zeichen: auf die Präsentation. Bertolt Brechts Verfremdungseffekt, die Abweichung von der Lineatur der Stereotypen, die Konzentration auf den Körper und die Einführung einer »anderen« Ausdrucksform gelten auch hier.

Die Macht der Skulptur ist ihre Eigenrealität, die ihre gesteigerte »Anwesenheit« hervorruft, die Anschauung ihres Andersseins in den Zeichen der Introspektion. Für einen Augenblick scheint das Leben immer wie angehalten aus einer heillos überbordenden Bilderflut der Wirklichkeit, und dann ist die Wirklichkeit auch wieder weit fort. Und alle Fragen richten sich auf den Blick nach innen. Geradezu axiomatisch ist dieser Zug in Muecks Figuren greifbar. Morphologisch erdacht ist diese bis an die Grenze der Traumatisierung geführte Vorstellung eine Grundgestalt des Werks mit all ihren Assoziationen.

Eine dieser Assoziationen ist die autistische Anrührung der Figuren, ihre undurchdringliche Expressivität, die wir in jenem »äußersten Erscheinen« wahrnehmen. Die Skulptur, die der Künstler *Ghost* nennt, spiegelt vollkommen ihre Psyche der Verlegenheit, der Scham, des Unbehagens und der Zurückgezogenheit. Das übergroße Mädchen im Badeanzug ist sich auf geradezu unheimliche Weise bewusst, dass sie ausgeschlossen, dass ihre körperliche, auffallend überbetonte Unzulänglichkeit ihr eigenes Gespenst geworden ist. Alles an dieser Erscheinung verkörpert Abseits-

**16 Man in Blankets** 2000
Mixed media
43.1 x 59.7 x 71.2 cm; 17 x 23½ x 28 in.
Ed. 1/1
Marguerite and Robert Hoffman, Dallas

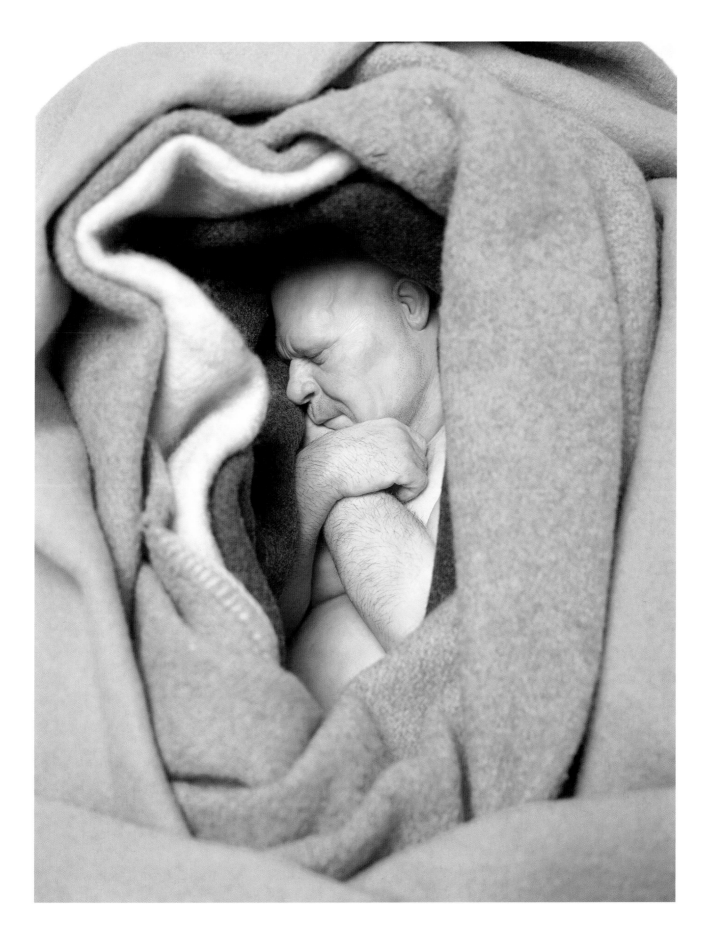

stehen, Verlust der Gleichwertigkeit, die Verborgenheit des Sich-Nicht-Einlassens, die unverborgene Empfindung, nicht erobert zu werden: Parabel einer Niederlage. Und auch hier ist alles Beschreibende verbannt. Die komplementären Codes, die Kleidung, die Mode, die Flut der gesellschaftlichen Konventionen, die Ereignisse des gegenwärtigen Kulturprozesses lassen sich in Muecks Skulpturen nicht einlösen. Es gibt nichts zu übersetzen. Das ganze sekundäre Denken ist angehalten. An seine Stelle tritt eine einzige Metapher, die des dichten Schweigens, in dem die Stimmen des Draußen schon zum Vorhof einer anderen Welt gehören.

Die Beziehungen des Menschen, die abstrakter werden – Beziehungen, in denen die Vereinzelung die Kraft des Normativen gewinnt –, spiegeln sich zweifellos in Ron Muecks Werk wie die Dissonanz der übergreifenden Prämissen von der Virtualität und synthetischen Vorstellungskraft unseres Lebens. Ohne zu moralisieren, ohne komplexe Symbolik appellieren diese Arbeiten an die Intuition, die poetische Verklärung. Ihr ikonischer Impuls wandelt die körperliche Realität in ein Bild, das sich nicht subsumieren lässt und dennoch in jeder dieser Skulpturen auf unterschiedliche Weise als Allegorie anwesend ist. Referenziell ist dabei das gleichzeitig vorhandene Wechselspiel zwischen dem Körper und dem über seine anthropomorphen Darstellungen hinausreichenden Bild.

Man betrachte nur *Man in a Sheet, Man in Blankets* oder *Woman in Bed:* alles Darstellungen, an deren Anfang und Ende der Ausdruck eines langsamen Abschieds steht. Die physische Hülle absorbiert beinahe nichts aus der Außenwelt. Der Stoff, der den Körper umgibt, bildet seine Grenzzeichnung. Metapher der Verletzlichkeit – eine dünne Linie, die den Körper vom Draußen trennt, mehr nicht. Ein Kokon, der die Leichtigkeit der Verhüllung nun zusätzlich als instabile, angreifbare Physis des Körpers impliziert. Und darum ist das Verhüllen und Verdecken eine Schwellenstufe des Nichtgegenwärtigen, das, was ich anfangs das Verweisen nannte: die Unsicherheit, Unwägbarkeit, Paranoia, selbst die Negation von kindlich und alt.

Mit einem seiner jüngsten Werke schuf Ron Mueck ein Bildnis, das die Verletzbarkeit allen Werdens in einer geradezu archetypischen (jedoch nicht fernen, atavistischen) Skulptur darstellt: *Swaddled Baby;* das ist ein winziges, eingewickeltes Kind, ein schlafendes Kind, von dem wir nur das Gesicht sehen. Wovon dieses Bild spricht, ist die zerbrechliche Subtilität des Körpers, die Phantasmagorie seines Ursprungs. Was wir sehen, kreist um sich selbst. Das Schlafen, das das Erwachen bezeichnet, die Anmut, die unsere Ergriffenheit auslöst, die Weichheit des Gesichts, das sich keinem Zeichen öffnet. Auf der Suche nach Referenzen finden wir in dieser Morphologie die eine, zu entdeckende, affektive Anwesenheit von Constantin Brancusis *Neuge-*

**30 Swaddled Baby** 2002
Mixed media
Baby: 18.4 x 21.6 x 49.5 cm;
7 1/4 x 8 1/2 x 19 1/2 in.
Pillow: 15.2 x 73.7 x 44.5 cm;
6 x 29 x 17 1/2 in.
Private collection

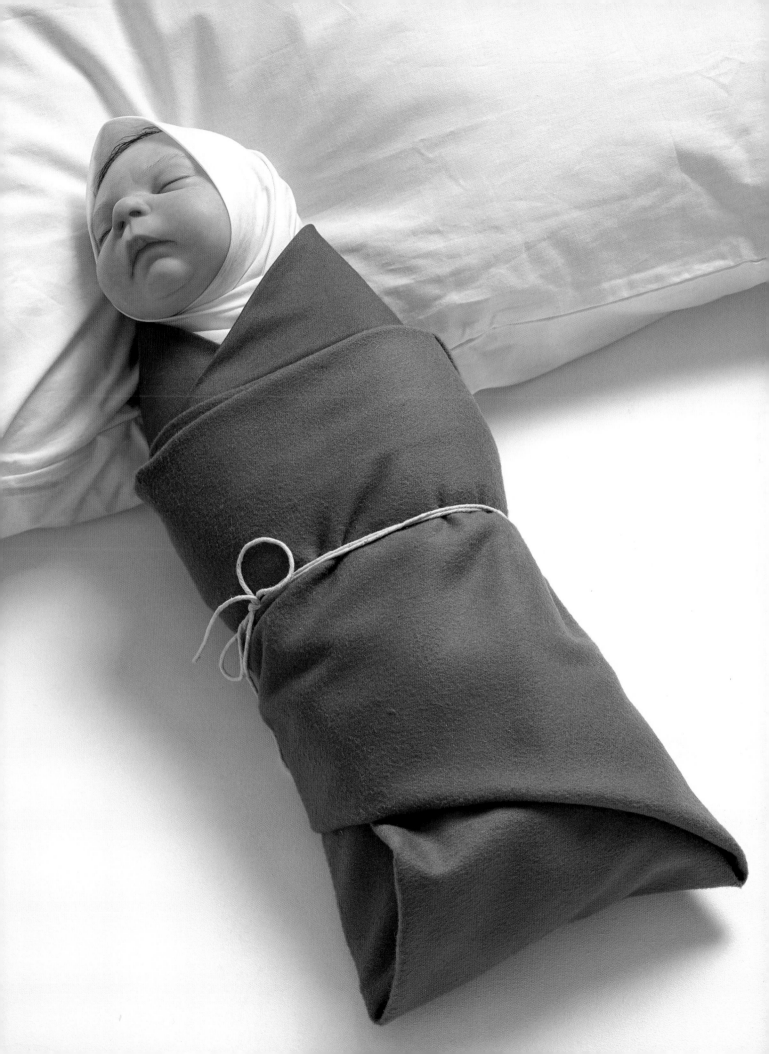

*borenem:* reinste Formen, die nichts als die Essenz des Lebens symbolisieren. Und dennoch enden in Ron Muecks winziger Skulptur alle Reisen und kunsthistorischen Entdeckungen. Jenseits des Verstehens und jeder Komparatistik ist diese Darstellung ein kleiner irdischer Stern, der Übereinstimmung heißt, Verstehen ohne Sprache.

Was sieht der kleine Junge, der sich verstohlen in einem Spiegel wieder sieht? Fragt er sich, was sein wird, betrachtet er sich wirklich? Begegnet ihm durch den Spiegel das Draußen der Welt? Ron Muecks *Crouching Boy in Mirror* spielt mit der Emotion des Spiegelbildes, dem Betrachten und dem Betrachtetwerden. Der Junge scheint bloß zufällig da, und das Draußen der Welt ist ein offenbar nur abstrakter Raum. Die Metapher der Skulptur ist der Widerschein, der Blick, der sich im Spiegel betrachtend verändert. Hier sind das Unbewusste, die Inklusion der Aufführung, die Verführung und Inszenierung, die Leichtigkeit und die Schwere, mit der wir in den Spiegel sehen, ausgeschlossen. Auf einmal ist die Welt nur Welt, der Raum wiederholt sich endlos, und jenseits von Voyeurismus, narzisstischer Ungeduld und unseren Idiosynkrasien ist der Spiegel leer und nichts als die Wiederholung eines kleinen Körpers, der eine Skulptur ist, aber die Illusion von Leben spiegelt.

Verborgene Seele – verborgene Mimesis. Denn man kann sich des Gedankens nicht erwehren, dass diese Skulpturen selbstreflexive Ideen verkörpern, dass sich hinter der Folie des Hyperrealismus die Innerlichkeit einer, wenn auch inkommensurablen Autobiografie verbirgt, die einer Initiation gleich das Subjekt erfindet. Die Lebensnähe dieser Werke oder die Empfindung – »dem Leben zurückgegeben« – ist eben auch nur im Schock, in der Verblüffung über so viel vorhandener, gar sprechender Miene anwesend. Aber diese Art Realismus behaupten Ron Muecks Skulpturen nicht: ihre Lebensnähe – ex negativo und ganz imaginär. In ihrer immer gleichen Vollkommenheit erscheint das Fragmentarische, das Unerfüllbare umso schärfer. Wer diese kritische Aneignung nicht sieht, dem entgeht der hier anwesende Blick auf die Welt. Autarkischer Realismus, das ist nur die vorhandene Blöße, das Jetzt der Skulptur.

In einem der früheren Werke Ron Muecks, der 1996 entstandenen Skulptur *Dead Dad*, bricht sich begreifendes Verstehen in der Anatomie des Schmerzes. Die bloße Figur des toten Vaters, knabenhaft verkleinerte Anatomie, ist das Memento mori einer Trauerarbeit, und jeder Versuch stummer Übereinstimmung versagt. Der Moment der Ergriffenheit verschließt sich über allen Reflexionen. In diesem Werk wird der tote Körper paradoxerweise zum verletzbarsten aller Bilder des Menschen. In seinem Widerschein erscheint Leben – Leben, das eben noch war, das jetzt nicht

mehr ist – rigoros fern, als Fremdheit gar. Die Emphase heißt reines, ausgelöschtes Leben – und dennoch: Eine unsichtbare, undurchdringliche Hülle umgibt den Körper. Wieder ist es der Raum, der die Ferne des Bildes erzeugt. Es ist das Achronische, die angehaltene Zeit, das, was nicht sein kann, das, was Leben und Tod als Anamorphose eines Bildes vereint. Der auf dem Boden liegende kleine Körper scheint einerseits eine ganz »unausgedachte« Darstellung (seine Natur), andererseits jedoch eine Ikonografie der diesseitigen Endlichkeit, die das Physiologische und die Materialität des Leibes übertrifft. Mysterium und einstürzender Himmel.

*Dead Dad*, diese Skulptur ungeheurer Einsamkeit, sagt uns, dass das Unabbildbare einen Bann ausüben kann, dass das Anderssein des Kunstwerks das Sprachlose berührt, und wenn wir eine Behauptung dieser Art Einsamkeit bedenken, gehört es zu unserer Empfindungsfähigkeit, die Anwesenheit existenzieller Vertrautheit zu verklären. Es gelingt uns beinahe jede Axiomatik. Dennoch führt uns die Skulptur an den Ort zurück, in dem nur sie spricht. Ein Bild, das vor allem über die Anatomie und Pathologie hinausweist. Wir schauen in ihr das Unsichtbare im Sichtbaren.

Folgende Seiten / Following pages
**26   Man in a Boat**   2002
Mixed media
Figure: 75 cm; 29$^{1}/_{2}$ in.
Boat: 421.6 x 139.7 x 122 cm;
166 x 55 x 48 in.
Anthony d'Offay, London

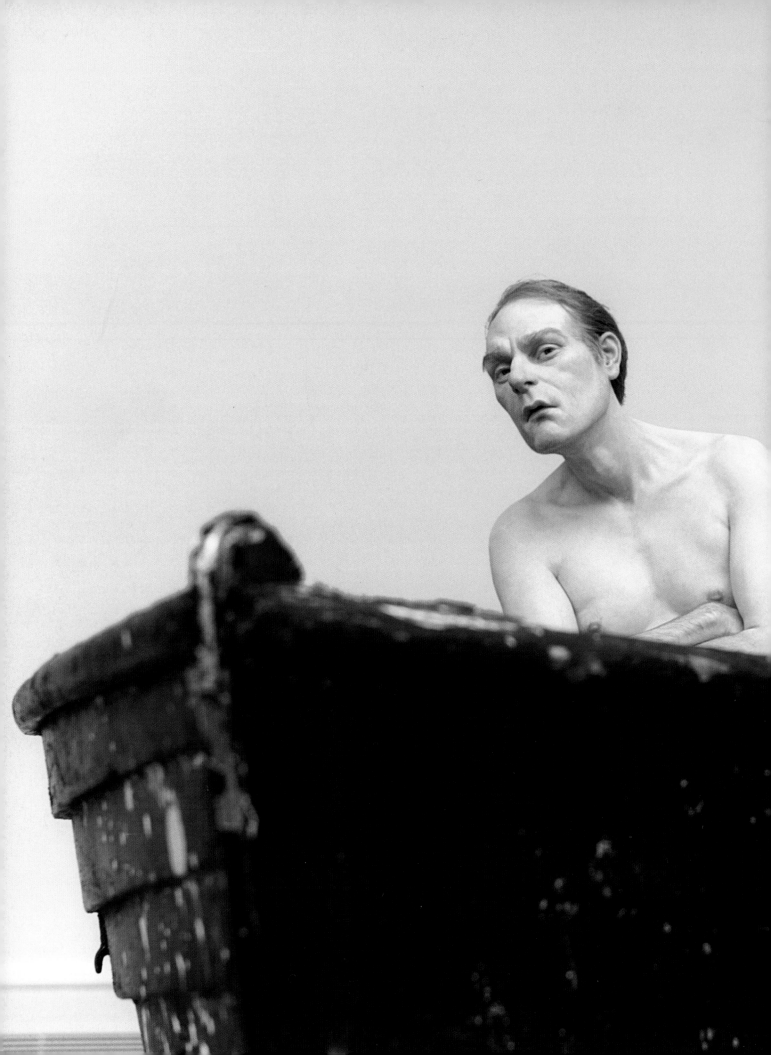

# On Several Sculptures by Ron Mueck HEINER BASTIAN

*"Beneath the dark whir of the gryphon's beating wings—between capture and emotion—we imagined the concept of consciousness."* <span>ABY WARBURG</span>

Almost completely veiled in a white sheet, the concealed, undeniably enigmatic figure gazes into the depths of its soul. Where else should it look? In this encounter with solitude, the fixed intentness of the unresponsive eyes and, above all, the passive, even humble, meditative posture make the figure's closeness seem removed to an immeasurable distance. Perhaps it is this duality to do with nearness and unapproachability, silence and utterance, the unspoken and the stated, which is the key to Ron Mueck's sculptures. Their references are certainly not historical, rather analogous to projections of the artist's highly contemporary perception. Yet many of our questions about this kind of "human-image-making" are of a pyscho-pathological nature and generate only synthetic meaning.

The shrouded figure in *Man in a Sheet* reflects a spiritual condition that does not deny the darker sides of the *vita contemplativa*. *Alone* is one way of formulating it, *inversion* is another. *Alone* brings one's own condition of loss into close-up. *Inversion*, on the other hand, suggests an image of allegorical presence. We have no way of knowing whether this radically reduced figure of a man is battling the agony of an inner monologue, or trying to achieve the mystery of an enigma by emphasizing his inadequacy. And what is this enigma? A reality which hides behind the idea of reality? Because the sculpture is not descriptive, the moment of appropriation, the moment of impact, is part of what it asserts. As we see it, this work, completed several years ago, seems to be saying that the world is imaginary.

For some reason we are peculiarly attracted by this kind of poetic archetype, in which a silent, almost invisible figure seems to point to something unutterable or absent. The man crouching beneath the linen—we can only see his face—is withdrawn into himself as if into a shroud. Yet he evokes a feeling of life and a real sense of temporal existence through the solitude that surrounds him. How much desire, recognition, submission, or inner conflict the image is intended to convey is impossible to determine; his expression suggests a hollow emptiness and a distant premonition. Life is certainly one of the sculpture's fragile assertions and allusion and expectation are strong forces. It remains unclear whether this heightened sense of mystery the work evokes is actually "present" or whether it should be thought of as a moment of epiphany. The more we examine the sculpture, the more strongly we feel the effect of its emotional existence, and the absence of something we cannot define, some unanswerable question.

**26 Man in a Boat** 2002
Detail
Mixed media
Figure: 75 cm; 29$^{1}/_{2}$ in.
Boat: 421.6 x 139.7 x 122 cm;
166 x 55 x 48 in.
Anthony d'Offay, London

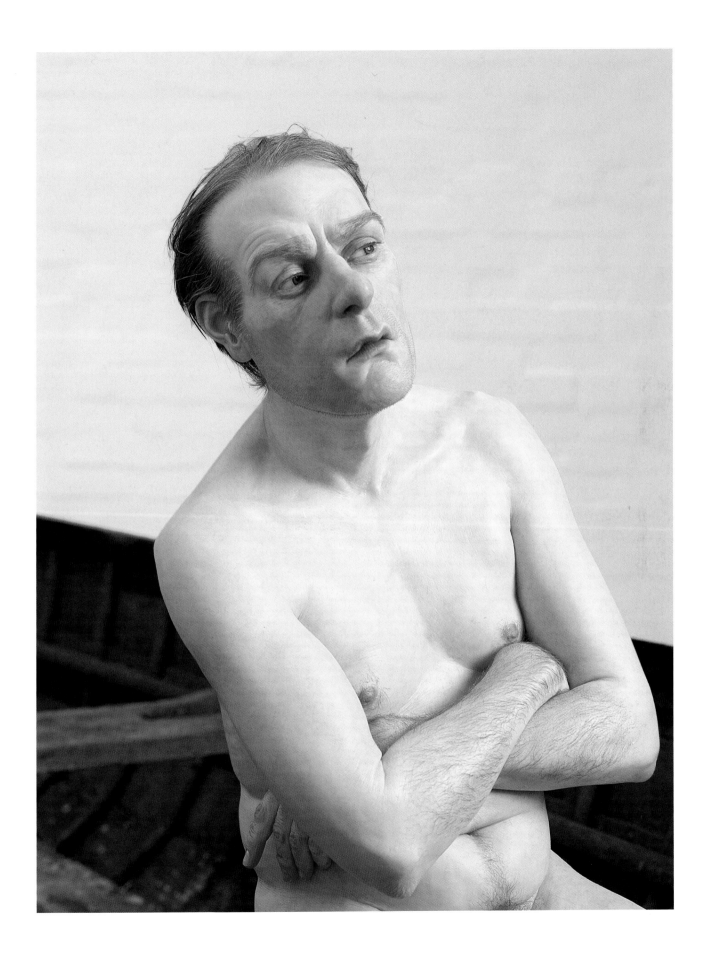

A further tendency in the artist's work is to be found in his sculpture, *towards the enigmatic*, where it is the technique of representation that breaks the grip of the sculpture's inner monologue and demands the echo of the viewer's response. The realism of Ron Mueck's work is changed by the interaction of the spectator, thus adding another temporal quality to its realization. Although Mueck's sculpture is most often admired for the factual precision of its representation, it is not the much-hyped, uncannily lifelike quality that distinguishes it from that of other artists with a similar interest in verisimilitude. What sets Mueck's sculptures apart is their credible existential illumination of the circumstances of life. Devoid of moralistic overtones, they exist as a kind of gravitational offshoot of the real world.

The recovery of a new identity from the unsurpassed richness of material reality is one of the basic premises of the artist's work. How does one imbue a dead body in a film still with a sense of life? The viewer may feel a fleeting irritation with the code which allows him to envisage the image as simultaneously both living and dead. The living aspect contains its eloquence, the power which raises it from the status of a simple representation into something alien and strange. It has often been suggested that this enigmatic quality is part of the attraction of Ron Mueck's figures. At the same time what is actually lifeless, inanimate, is transformed into something physiologically believable. The eye of the beholder swings between the sheer tangibility of the lifeless body and the psychological need to give valid form and meaning to the forces of life.

Our perceptions do not seem to be guided by iconic neutrality or unrelenting mystery but as if by a sense of deepening shadow, which causes us to reach out towards the unutterable and sometimes towards pain. This vision, common to all Mueck's sculptures, suggests that behind the world of rational perception lies a parallel world of imagination. It is not a world where life disappears; on the contrary, its voice can be heard speaking out from its place in an animate matter with absolute clarity.

Ron Mueck's *Man in a Sheet*—no particular significance or categorization should be attached to the example—uses appearance and gesture as a means of conveying its isolation and loneliness. Even if we only grasp this intuitively, every gesture becomes a means of symbolic expression. We read these congruencies as indicators of human alienation, and interpret them as references to the absent, quotidian world. Events, the circumstances of everyday interaction, the presence of symbol and myth have all been eliminated. The body language of Mueck's sculpture has become associated with loneliness and abandonment. If we are to understand this loneliness, we have to be aware that it may be deliberately self-chosen, and also that

**15  Seated Woman**  1999/2000
Mixed media
Figure: 58 x 28 x 39 cm;
22⁷/₈ x 11 x 15³/₈ in.
Overall: 75 x 62 x 56 cm;
29¹/₂ x 24³/₈ x 22 in.
A/P
Private collection

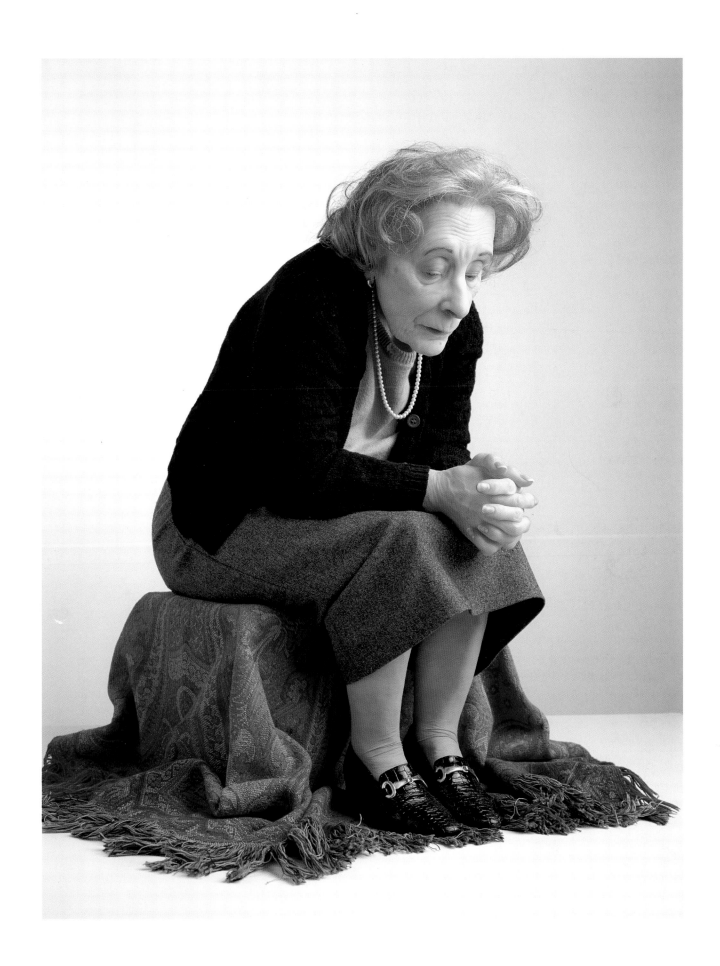

it is stamped with grief, melancholy and doubt. The alienation of the individual who treads uneasily in the environment in which he finds himself, the inevitable absurdity of a strange world that can only be grasped in fragments, are examples of but a small part of the vast range of the characteristic attributes of Mueck's work.

When I talk about absurdity I mean the kind which engages with reality, not the kind which involves transfiguration. In the sculpture entitled *Shaved Head*, a crouching nude figure reveals nothing. His physiognomy is similar to that of *Man in a Sheet*. The pose seems compulsive, the situation irreversible. He appears to have been plucked from the river of existence—that is the viewer's initial impression of this image. Hermetically withdrawn, his unseen gaze is fixed on the ground. The bowed body conceals all expression. These are the only signs of dissolution. And the silence. A silence only autism can provoke. Only that hallucinatory, echoless, spellbound pose expresses inner disturbance. Similar spellbound images occur in the work of Edvard Munch, where the persuasive voices of psychological disturbance never murmur warnings of the danger ahead, but point to initiation, resurrection and premonition. Here we see a similar powerful imagination and ability to envision images of darkness.

How different is the cautious optimism which dissolves the frozen moment in *Man in a Boat*. In this work the descriptive, still, melancholy presence often seen in Mueck's sculptures meets an imaginary horizon. All the figure's immobility, silence and introversion is set in narrative motion. The man in the boat is a very small nude figure, who seems to test his own world of perception by riding (in a real boat) through the "reality of the world." Thus—or in some similar way—we see this traveler, spellbound by the unsettling logic of illusion. He seems to view his fate in the imaginary distance with a skeptical misgiving. His eyes express composure, their unblinking gaze, responsibilities and equanimity. It could be that his boat is intended as a metaphor for the predetermination of our own journey. If so it would be similarly mute and the traveler would have the same psychic ambiguity as the artist's figures: tossed back and forth between fear and melancholy, between a fairytale and a sibylline world. But perhaps here traveling means "venturing out" and the monologue of the man in the boat is a soliloquy, a process of discovery. Is it not true that this artist's figures are first and foremost images of an, as yet unknown, frustrated Pyrrhon of the twenty-first century?

It is in their tactile relationship to reality that Mueck's sculptures develop their fundamental mystery. Their archaic image becomes fused with the extraordinarily expressive power of the psychic. Thus the man in the boat, by virtue of the incon-

**18  Standing Man**  2000
Mixed media
116.8 x 50.8 x 38.1 cm; 46 x 20 x 15 in.
Private collection, Milan

58

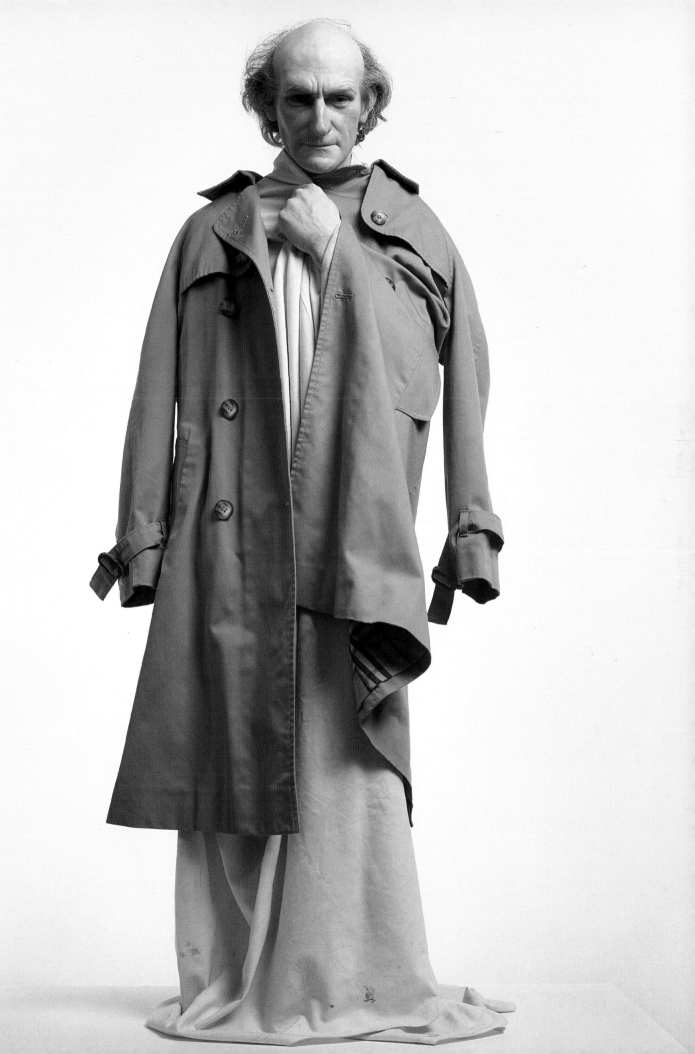

gruity between his childlike proportions and his adult facial expression, is once again condemned to a painful solitude beyond the symbolic image of loneliness.

Everything in this work seems, subtly or even hesitantly, to evoke the Other, the invisible image which is hidden behind the verisimilitude and which indeed may never be found. Nowhere to be seen is the assertive force of innovation or even a suggestion of the merely makeable. The loneliness of the man in the boat is immeasurable, a place of chimeras. The question of what the man sees remains unanswered; it is quite explicit and yet it is the echo of his own imagination. One of these projections of the imagination is the space around him which, as a result of the intensity of the physical relativity involved, becomes an immense, meaningful expanse. As viewers we are drawn into this space which is not to be thought of as complementary, but as consciously engineered: a world of pure allusion.

This dialogue with the space does not express a yearning for real space, it is rather a monologue on an imaginary space which vanishes, emanates from the sculpture and is drawn back into it again. In any examination of the work of Ron Mueck it is necessary first to explore its stillness for the space that surrounds the work is not the space of light and shadow, of echo and resonance, but the unidentifiable space of fiction. It refers us back to the figure and its proportions, to its gestures and facial expressions (and their meaning) and to its presentation. Bertolt Brecht's alienation effect—deviation from the stereotype, concentration on the body, introduction of a "different" form of expression—applies equally well here.

The power of the sculpture lies in its own sense of reality, which heightens its presence and, through symbols of introspection, emphasizes our perception of it as essentially different. For a brief moment life seems like a sudden "still" cut from an overflowing tide of images which is halted and subsequently flows on again. All questions are directed towards that inward gaze. It is an almost palpable feature and virtually axiomatic in Mueck's work. Morphologically, this concept of an imagination bordering on the edge of trauma, with all its associations, is one of his fundamental forms.

One of these associations is the touching, almost autistic quality of his figures which manifest an extreme degree of impenetrable expressiveness. The sculpture entitled *Ghost* perfectly reflects the psychological state of embarrassment, shame, discomfort and withdrawal of the oversized girl in a bathing suit. She is uncannily aware of being excluded and that her visibly overstated inadequacy has become her own ghost. Everything about this figure embodies retirement, renunciation of parity, a desire not to be involved and a determination not to be conquered: a parable of

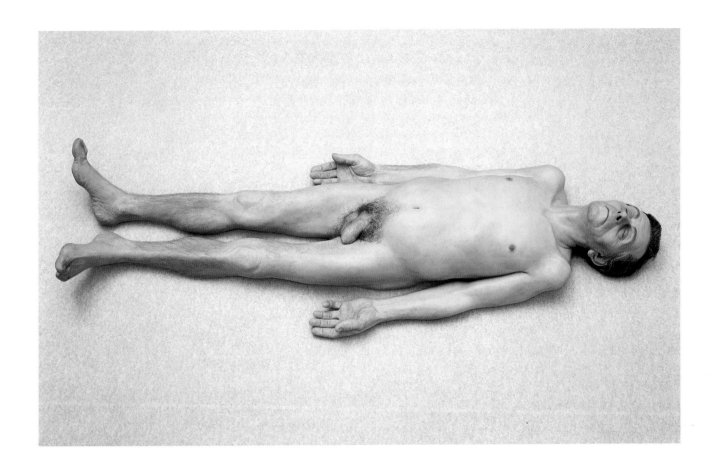

defeat. Here, too, every literary element is banished. There are no codes to use for comparison in the way of clothing, fashion, social convention or contemporary culture. There is nothing to translate. Secondary thinking has come to a halt. It is replaced by a single metaphor of dense silence, and the voices which penetrate it from the outside sound as if they emanate from the forecourt of another world. Human relationships which become increasingly abstract—relationships in which isolation becomes the norm—are undoubtedly reflected in Mueck's sculpture, as are the two broad but dissonant premises of life: its essential nature and the synthetic power of the imagination. Without moralizing or using complex symbolism, these works appeal to the intuition and to poetic transformation. The iconic impulse in these sculptures transforms physical reality into an image that cannot be subsumed, and yet is also present in various ways as allegory. This is summed up in the interplay between the body and the image which transcends its anthropomorphic representation.

**4   Dead Dad**   1996/1997
Mixed media
20 x 38 x 102 cm; 7 7/8 x 15 x 40 1/8 in.
The Saatchi Gallery, London

For further examples one has only to turn to *Man in a Boat, Man in Blankets* or *Old Woman in Bed,* all images which begin and end with the expression of a gradual farewell. Their physical wrappings absorb almost nothing of the external world. The fabric that envelops the body describes only its outline. It is a metaphor of vulnerability, a thin line which separates the body inside from the outside, nothing more. A cocoon which uses the lightness of the veiling to imply the unstable, vulnerable, physical nature of the body within. In this context veiling and concealment represent a step across the threshold of non-presence towards the state identified earlier as allusion: imponderability, uncertainty, paranoia, even the denial of the childlike and the old.

In one of his most recent works Ron Mueck created an image of universal vulnerability in the truly archetypal *Swaddled Baby:* a tiny, sleeping child, wrapped in swaddling clothes, of whom we can only see the face. The message of this image is the fragile subtlety of the body and the phantasmagoria of its origins. What we see revolves about itself. The sleep that heralds awakening, the touching grace, the softness of the face which gives nothing away. Searching for morphological antecedents, the single effective presence that comes to mind is Brancusi's *Newborn Infant* with its purity of form which symbolizes nothing but the essence of life. All the art historical journeys culminate in Ron Mueck's tiny sculpture. Beyond the reach of comprehension or compassion this figure is a small terrestrial star which signifies accord, understanding without language.

What does the little boy stealing a glance in the mirror see? Does he ask himself what the future holds? Does he really look at himself? Ron Mueck's *Crouching Boy in a Mirror* plays with the sentiments engendered by the mirror image, the idea of seeing and being seen. The boy appears to be there merely by chance and the outside world is to him clearly only an abstract space. The metaphor of the sculpture concerns the reflection, the image that changes as it sees itself in the mirror. Here unconsciousness, theatricality, temptation, engineering, ease, difficulty—all the different ways we look in the mirror are excluded. All at once the world is only the world and space repeats itself endlessly. Beyond voyeurism, narcissistic impatience and our own idiosyncrasies, the mirror is empty save for the repeated image of one small body which reflects the illusion of life, but is in fact a sculpture.

Secret soul, secret mimesis. One cannot help thinking that these sculptures harbor ideas of their own and that concealed within their hyper-realistic plastic skin is an inner nature and autobiography to match, which has invented its subject in a kind of initiation rite. The lifelike quality of these works, or rather perhaps the sense of "life

**29  Crouching Boy in Mirror**
1999/2002
Mixed media
Boy: 43.2 x 45.7 x 28 cm;
17 x 18 x 11 in.
Mirror: 45.7 x 55.9 x 0.6 cm;
18 x 22 x ¼ in.
Private collection

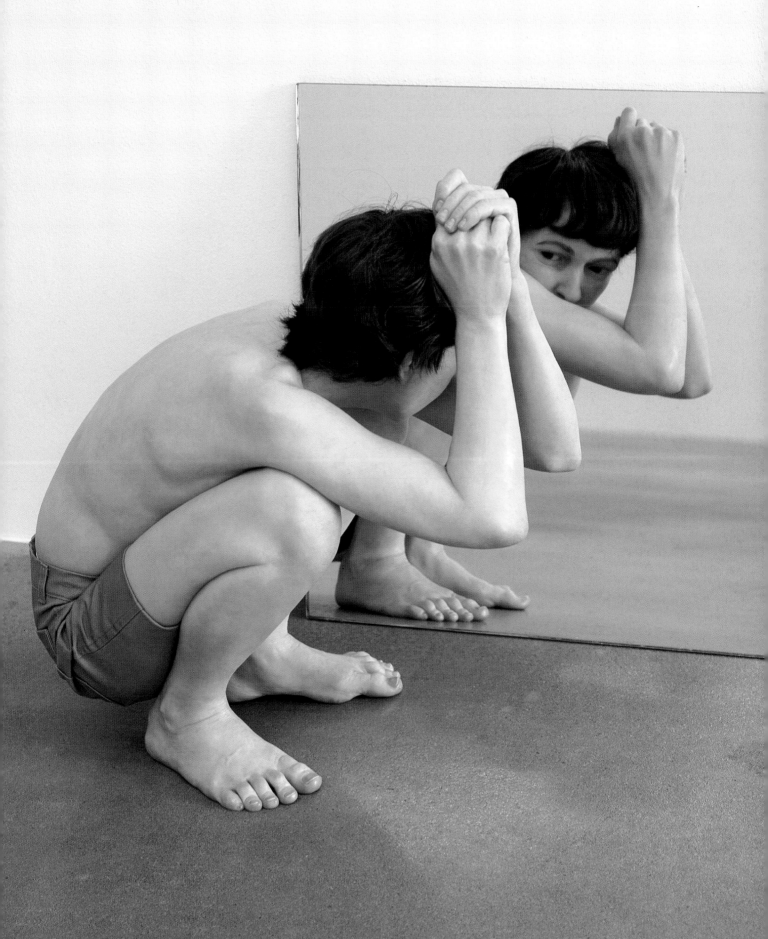

given back," causes a kind of shock and astonishment in the beholder at the existence of so much mimesis, so much likeness. Yet Ron Mueck's sculptures lay no claim to this kind of realism as an end in itself. Their life-like quality is "ex-negativo" and ruled by the imagination. Amongst so much consistent perfection the fragments and incomplete works stand out the more sharply. Those who do not understand this kind of critical annexation do not understand what it is to view the world this way. Mueck's autarchic realism is a self sufficient world of which he is the despot. His sovereignty is absolute.

In one of Ron Mueck's earlier works, *Dead Dad,* made in 1996, comprehension is broken down by the anatomy of pain. The naked body of his dead father reduced in size to boyish proportions is both a "memento mori" and a work of mourning. Every attempt to achieve tacit accord has failed. There is no turning back from this moment of deep emotion. Paradoxically, in this work the dead body becomes the most vulnerable of all human images. In its reflection life—life that was just there and is now gone—seems totally distant, even alien. The emphasis here is on life which has simply been extinguished—and yet: an invisible, impenetrable veil encompasses the body. Once again it is the space surrounding it which distances it from us. It is temporal, appearing to exist in a time which has stopped, which cannot be, but nevertheless unites life and death as the anamorphosis of an image. The small body lying on the floor seems, on the one hand, to be entirely an uninvented "natural" image, on the other, it belongs to the iconography of earthly mortality which exceeds the physiological and material aspects of the dead body.

*Dead Dad* is a sculpture of monstrous loneliness which tells us that the otherness of the work of art touches the unutterable. When we consider such an assertion of loneliness, we become capable of transfiguring the presence of existential familiarity. We succeed in accepting almost every axiomatic system. Yet in the end we are taken back to the place where only the sculpture can speak. This is an image which transcends anatomy and pathology. It permits us to see into the invisible realm beyond the visible.

**11   Man under Cardigan**   1998
Mixed media
44 x 47 x 63 cm; 17 3/8 x 18 1/2 x 24 3/4 in.
Vicki and Kent Logan Collection

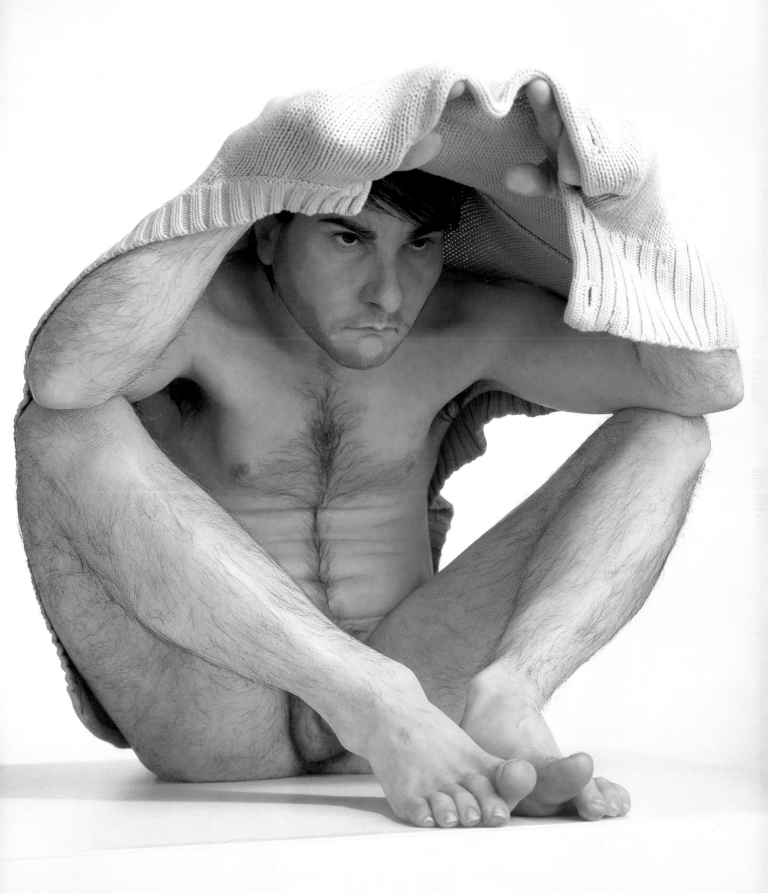

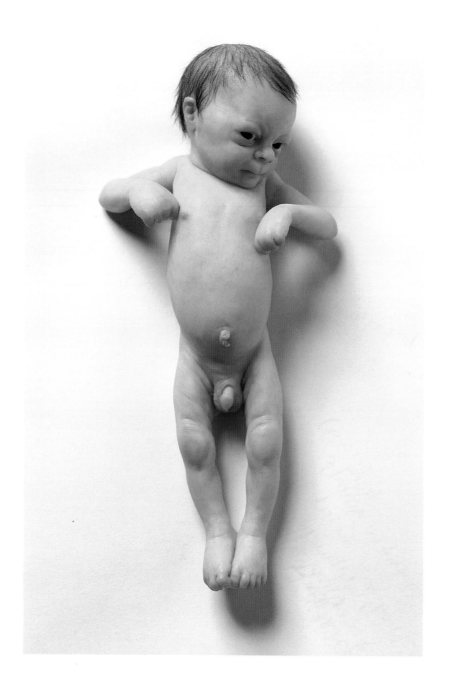

**20  Baby** 2000
Mixed media
26 x 12.1 x 5.3 cm; 10¼ x 4¾ x 2⅛ in.
A/P
Keith and Kathy Sachs, Philadelphia

**33  Baby on a Chair** 2004
Mixed media
Baby: 18.4 x 21.6 x 49.5 cm;
7¼ x 8½ x 19½ in.
Chair: 77 x 36 cm; 30¼ x 14⅛ in.
Collection Glenn Fuhrman, New York

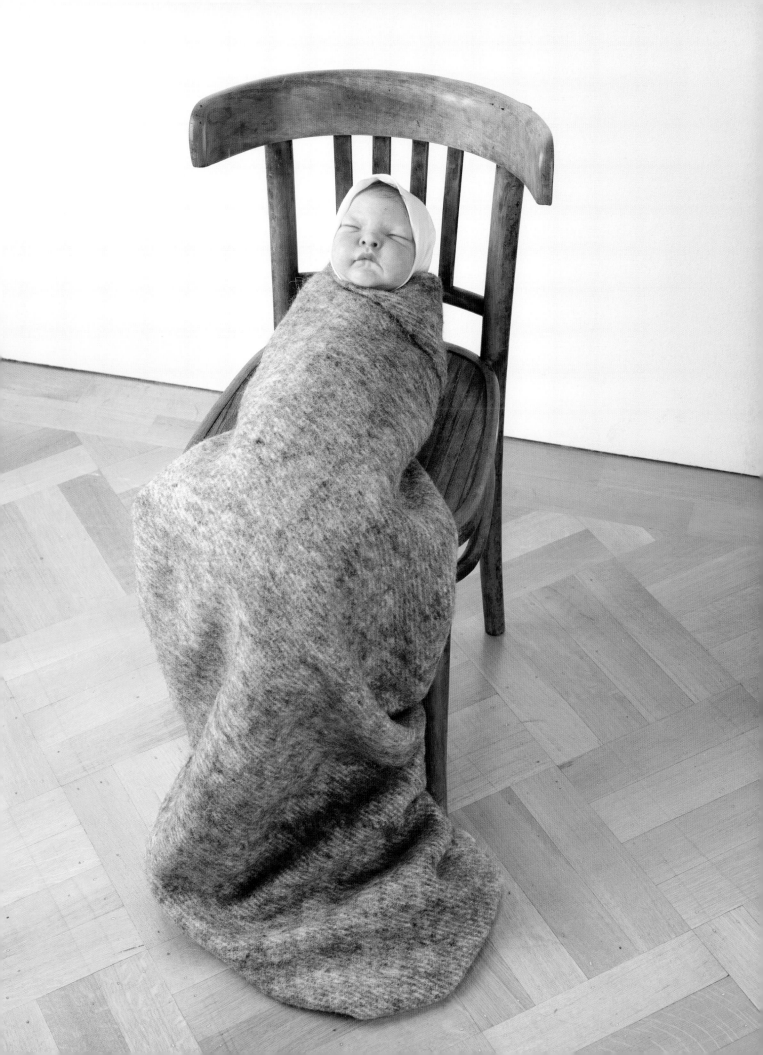

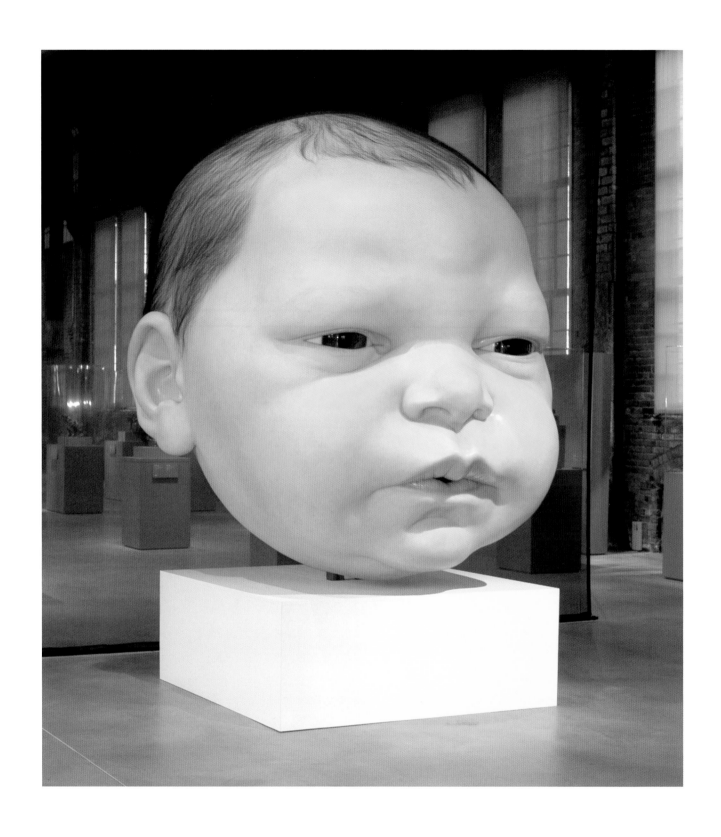

**32  Head of a Baby**  2003
Mixed media
254 x 219 x 238 cm; 100 x 86¹/₄ x 93³/₄ in.
National Gallery of Canada, Ottawa

# Catalogue raisonné

zusammengestellt von / compiled by   CÉLINE BASTIAN

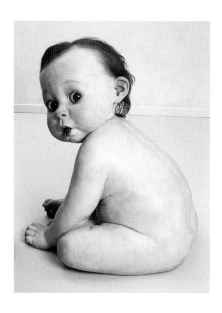

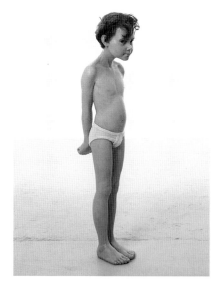

**1 Big Baby**

1996

Mixed media
85 x 71 x 70 cm; 33¹/₂ x 28 x 27¹/₂ in.

The Saatchi Gallery, London

**2 Pinocchio**

1996

Mixed media
84 x 20 x 18 cm; 33 x 7⁷/₈ x 7¹/₈ in.

Collection John and Amy Phelan

**Exhibition/Exhibition Catalogue**

2000    London, The Saatchi Gallery, *Ant Noises at the Saatchi Gallery: Part I, Damien Hirst, Sarah Lucas, Ron Mueck, Chris Ofili, Jenny Saville, Rachel Whiteread*, 20 April – 20 August, n.n., ill., n.p.

**References**

1998    The Saatchi Gallery (ed.), *The New Neurotic Realism*, London, ill., n.p.

1999    Richard Cork, Sarah Kent, and Jonathan Barnbrook (eds.), *Young British Art: The Saatchi Decade*, London, ill. p. 381.

2003    Jonathan Cape and The Saatchi Gallery (eds.), *100 – The Work That Changed British Art*, London, ill. 76, p. 157.

**Exhibitions/Exhibition Catalogues**

1996    London, Hayward Gallery, *Spellbound: Art and Film*, 22 February – 6 May, exh. as part of Paula Rego's installation, cat., n.ill.

1997    London, Royal Academy of Arts, *Sensation: Young British Artists from the Saatchi Collection*, 18 September – 28 December, cat. no. 66, n.ill.; further venues: Berlin, Neue National-galerie im Hamburger Bahnhof, Museum für Gegenwart, 30 September 1998 – 17 January 1999, not exh., cat. no. 66, n.ill.; New York, The Brooklyn Museum of Art, 2 October 1999 – 9 January 2000 (London and New York, one cat.).

2000    London, The Saatchi Gallery, *Ant Noises at the Saatchi Gallery: Part I, Damien Hirst, Sarah Lucas, Ron Mueck, Chris Ofili, Jenny Saville, Rachel Whiteread*, 20 April – 20 August, n.n., ill., n.p.

**References**

1996    John McEwen, "Something Disturbing in Silicon," *The Sunday Telegraph*, 18 February.

1998    The Saatchi Gallery (ed.), *The New Neurotic Realism*, London, ill., n.p.

1999    Richard Cork, Sarah Kent, and Jonathan Barnbrook (eds.), *Young British Art: The Saatchi Decade*, London, ill. p. 383.

2002    London, National Gallery, *Ron Mueck*, ill. p. 42, comm. by Susanna Greeves p. 43.

2003    Jonathan Cape and The Saatchi Gallery (eds.), *100 – The Work That Changed British Art*, London, ill. 75, p. 156.

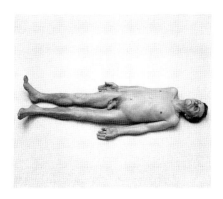

**3  Mongrel**

1996

Mixed media
40 x 61 x 20.3 cm; 15 ³/₄ x 24 x 8 in.

Private collection, London

**4  Dead Dad**

1996/1997

Mixed media
20 x 38 x 102 cm; 7 ⁷/₈ x 15 x 40 ¹/₈ in.

The Saatchi Gallery, London

**Exhibitions/Exhibition Catalogues**

1997    London, Royal Academy of Arts,
        *Sensation: Young British Artists from the
        Saatchi Collection,* 18 September –
        28 December, cat. no. 65, ill. p. 127;
        further venues: Berlin, Neue National-
        galerie im Hamburger Bahnhof, Museum
        für Gegenwart, 30 September 1998 –
        17 January 1999, cat. no. 65, ill. p. 127;
        New York, The Brooklyn Museum of Art,
        2 October 1999 – 9 January 2000
        (London and New York, one cat.).

**References**

1998    The Saatchi Gallery (ed.), *The New
        Neurotic Realism,* London, ill., n.p.
        Craig Raine, "To the Life," *Modern
        Painters,* autumn, ill. p. 20, comm.
        pp. 21, 22.

1999    Richard Cork, Sarah Kent, and Jonathan
        Barnbrook (eds.), *Young British Art: The
        Saatchi Decade,* London, ill. pp. 384–385.
        San Francisco, California College of Arts
        and Crafts, *Spaced Out: Late 1990s
        Works from the Vicki and Kent Logan
        Collection,* comm. by Lawrence Rinder
        pp. 7, 8.

2001    Jerry Saltz, "Like Life," *Village Voice,*
        12 June, ill. p. 61.
        National Gallery, London (ed.),
        *Ron Mueck,* ill. p. 45, comm. by
        Susanna Greeves pp. 47, 53, 60.

2003    The Saatchi Gallery (ed.), *100 – The Work
        That Changed British Art,* London, ill. 73,
        pp. 152, 153.
        Hans Pietsch, "Allein mit sich selbst,"
        *Art,* May, ill. p. 63, comm. p. 62.

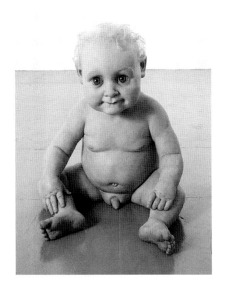

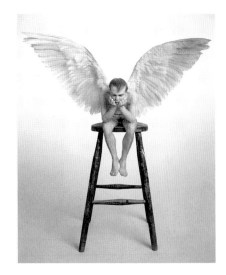

**5  Big Baby II**

1997

Mixed media
85 x 71 x 70 cm; 33 ½ x 28 x 27 ½ in.

Caldic Collectie, Rotterdam

**6  Big Baby III**

1997

Mixed media
86 x 81 x 70 cm; 33 ⅞ x 31 ⅞ x 27 ⅝ in.

Stefan T. Edlis, Chicago

**7  Angel**

1997

Mixed media
Figure: 110 x 87 x 81 cm; 43 ¼ x 34 ¼ x 31 ⅞ in.
Stool: 60 x 40 x 38 cm; 23 ⅝ x 15 ¾ x 15 in.

Marguerite and Robert Hoffman, Dallas

**Exhibitions/Exhibition Catalogues**

1999    Düsseldorf, Kunsthalle, *Heaven,*
30 July – 17 October, n.n., ill. p. 42;
further venue: Liverpool, Tate Gallery,
9 December 1999 – 27 February 2000
(Düsseldorf and Liverpool, one cat.).

2000    London, The Saatchi Gallery, *Ant Noises
at the Saatchi Gallery: Part I, Damien
Hirst, Sarah Lucas, Ron Mueck, Chris
Ofili, Jenny Saville, Rachel Whiteread,*
20 April – 20 August, n.n., ill., n.p.

2002    Rotterdam, Museum Boijmans Van
Beuningen, *Imagine, You Are Standing
Here in Front of Me: Caldic Collectie,*
23 November 2002 – 2 February 2003,
ill. p. 190.

2003    Helmond, Gemeentemuseum, *Child
in Time: Views of Contemporary Artists
on Youth and Adolescence,* 24 May –
7 September, ill. p. 8.

2005    Oostende, PMMK, Museum of Modern
Art, *Soul Inspired Art,* 15 July – 15 Sep-
tember.

**References**

1998    The Saatchi Gallery (ed.), *The New
Neurotic Realism,* London, ill., n.p.

1999    Richard Cork, Sarah Kent, and Jonathan
Barnbrook (eds.), *Young British Art:
The Saatchi Decade,* London, ill. p. 382.

**Exhibitions/Exhibition Catalogues**

1999    Düsseldorf, Kunsthalle, *Heaven,*
30 July – 17 October, n.n., ill. p. 43;
further venue: Liverpool, Tate Gallery,
9 December 1999 – 27 February 2000
(Düsseldorf and Liverpool, one cat.).

2000    London, The Saatchi Gallery, *Ant Noises
at the Saatchi Gallery: Part I, Damien
Hirst, Sarah Lucas, Ron Mueck, Chris
Ofili, Jenny Saville, Rachel Whiteread,*
20 April – 20 August, n.n., ill., n.p.

2002    Tokyo, The National Museum of Art,
*A Perspective on Contemporary Art:
Continuity and Transgression,* 29 Octo-
ber – 23 December, n.n., pl. 19–20, n.p.;
further venue: Osaka, The National
Museum of Osaka, 16 January – 23 March
(Tokyo and Osaka, one cat.).

**References**

1998    The Saatchi Gallery (ed.), *The New
Neurotic Realism,* London, ill., n.p.

1999    Richard Cork, Sarah Kent, and Jonathan
Barnbrook (eds.), *Young British Art:
The Saatchi Decade,* London, ill. p. 382.

**Exhibitions/Exhibition Catalogues**

1997    London, Royal Academy of Arts,
*Sensation: Young British Artists from the
Saatchi Collection,* 18 September –
28 December, exh., n.ill.;
further venues: Berlin, Neue National-
galerie im Hamburger Bahnhof, Museum
für Gegenwart, 30 September 1998 –
17 January 1999, exh., n.ill.; New York,
The Brooklyn Museum of Art, 2 October
1999 – 9 January 2000, exh., n.ill.
(London and New York, one cat.).

1998    London, Anthony d'Offay Gallery,
*Ron Mueck,* 29 April – 18 June, n.cat.

2000    London, The Saatchi Gallery, *Ant Noises
at the Saatchi Gallery: Part I, Damien
Hirst, Sarah Lucas, Ron Mueck, Chris
Ofili, Jenny Saville, Rachel Whiteread,*
20 April – 20 August, n.n., ill. on the
cover, n.p.

**References**

1998    The Saatchi Gallery (ed.), *The New
Neurotic Realism,* London, ill., n.p.
Regina von Planta, "Ron Mueck bei
Anthony d'Offay," *Kunst-Bulletin,*
May, ill.

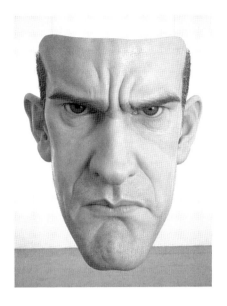

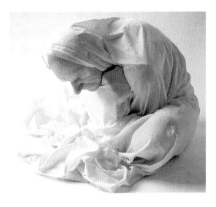

**8  Mask**

1997

Mixed media
145 x 137 x 106 cm; 57 x 54 x 41³/₄ in.

The Saatchi Gallery, London

**9  Man in a Sheet**

1997

Mixed media
34 x 48.5 x 50 cm; 13³/₈ x 19¹/₈ x 19³/₄ in.

Sammlung Olbricht

1999  Richard Cork, Sarah Kent, and Jonathan
       Barnbrook (eds.), *Young British Art:
       The Saatchi Decade*, London, ill. p. 494.
2000  Jörg Restorff, "Flügelwesen und Bruch-
       piloten: Von guten und bösen Engeln,"
       *Kunstzeitung*, no. 52, December, ill. p. 1.
2003  London, National Gallery, *Ron Mueck*,
       ill. p. 18, comm. by Colin Wiggins p. 19.
       Jonathan Cape and The Saatchi Gallery
       (eds.), *100 – The Work That Changed
       British Art*, London, ill. 77, p. 159.
       Hans Pietsch, "Allein mit sich selbst,"
       *Art*, May, ill. p. 57.

**Exhibitions/Exhibition Catalogues**

1997  London, Royal Academy of Arts,
       *Sensation: Young British Artists from the
       Saatchi Collection*, 18 September –
       28 December, exh., n.ill.;
       further venues: Berlin, Neue National-
       galerie im Hamburger Bahnhof, Museum
       für Gegenwart, 30 September 1998 –
       17 January 1999, exh., n.ill.; New York,
       The Brooklyn Museum of Art, 2 October
       1999 – 9 January 2000, exh., n.ill.
       (London and New York, one cat.).
1998  London, Anthony d'Offay Gallery,
       *Ron Mueck*, 29 April – 18 June, n.cat.
2000  London, The Saatchi Gallery, *Ant Noises
       at the Saatchi Gallery: Part I, Damien
       Hirst, Sarah Lucas, Ron Mueck, Chris
       Ofili, Jenny Saville, Rachel Whiteread*,
       20 April – 20 August, n.n., ill., n.p.

**References**

1998  The Saatchi Gallery (ed.), *The New
       Neurotic Realism*, London, ill., n.p.
       Craig Raine, "To the Life," *Modern
       Painters*, autumn, comm. p. 22.
1999  Richard Cork, Sarah Kent, and Jonathan
       Barnbrook (eds.), *Young British Art:
       The Saatchi Decade*, London, ill. p. 495.

**Exhibitions/Exhibition Catalogues**

1999  Kiel, Kunsthalle zu Kiel, *Unsichere Gren-
       zen*, 17 June – 29 August, n.n.,
       ill. pp. 18, 19, comm. by Beate Ermacora
       pp. 20, 21.
2001  Bremen, Neues Museum Weserburg and
       Gesellschaft für Aktuelle Kunst, *Ohne
       Zögern: Without Hesitation: Die Samm-
       lung Olbricht Teil 2*, ill. p. 183, comm. by
       Sabine Maria Schmidt pp. 182, 183.
2002  Essen, Ruhrlandmuseum, *Ebenbilder:
       Kopien von Körpern – Modelle des Men-
       schen*, 26 March – 30 June, cat. no. VI/16,
       ill., comm. by Jan Gerchow p. 280.
2003  Berlin, Berliner Medizinhistorisches
       Museum der Charité, *Gewissenlos –
       Gewissenhaft: Menschenversuche im
       Konzentrationslager*, 24 April – 27 July,
       cat., n.ill.
       Berlin, Neue Nationalgalerie im Ham-
       burger Bahnhof, Museum für Gegenwart,
       *Ron Mueck*, 10 September – 2 November.
2004  Fellbach, Alte Kelter, *Ich will, dass du mir
       glaubst!*, 9. Triennale Kleinplastik Fell-
       bach, ill. p. 91.

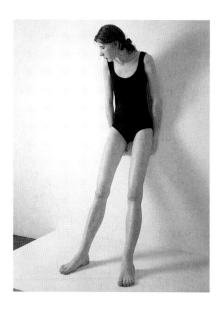

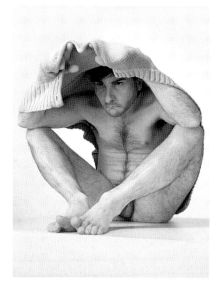

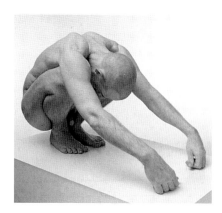

**10   Ghost**

1998

Mixed media
202 x 65 x 99 cm; 79 1/2 x 25 1/2 x 39 in.

Tate Gallery, Liverpool

**11   Man under Cardigan**

1998

Mixed media
44 x 47 x 63 cm; 17 3/8 x 18 1/2 x 24 3/4 in.

Vicki and Kent Logan Collection

**12   Shaved Head**

1998

Mixed media
49.5 x 36.7 x 83.8 cm; 19 1/2 x 17 1/4 x 33 in.

Sammlung Hoffmann, Berlin

**Exhibitions/Exhibition Catalogues**

1998   London, Anthony d'Offay Gallery, *Ron Mueck*, 29 April – 18 June, n.cat.

2005   Sheffield, Millennium Galleries, *The Human Figure in British Art from Moore to Gormley*, 22 January – 17 April.

**References**

1998   Craig Raine, "To the Life," *Modern Painters*, autumn, ill. p. 23, comm. p. 22.

2002   London, National Gallery, *Ron Mueck*, ill. p. 61, comm. by Susanna Greeves p. 59.

**Exhibitions/Exhibition Catalogues**

1998   London, Anthony d'Offay Gallery, *Ron Mueck*, 29 April – 18 June, n.cat.

1999   San Francisco, California College of Arts and Crafts, *Spaced Out: Late 1990s Works from the Vicki and Kent Logan Collection*, 17 April – 5 June, pl. 5, p. 29, comm. by Lawrence Rinder pp. 7, 8.

2005   Denver, Denver University, Victoria H. Myhren Gallery, *In Limbo*, 13 January – 11 March, ill. p. 41.

**Exhibition/Exhibition Catalogue**

2001   Venice, Corderie, *La Biennale di Venezia, 49. Esposizione Internazionale d'Arte: Platea dell'Umanità/Plateau of Humankind*, 10 June – 4 November, vol. 1, ill. p. 108.

2003   Berlin, Neue Nationalgalerie im Hamburger Bahnhof, Museum für Gegenwart, *Ron Mueck*, 10 September – 2 November.

**References**

2002   London, National Gallery, *Ron Mueck*, ill. p. 48, comm. by Susanna Greeves pp. 49, 51.

2003   Hans Pietsch, "Allein mit sich selbst," *Art*, May, ill. p. 5.

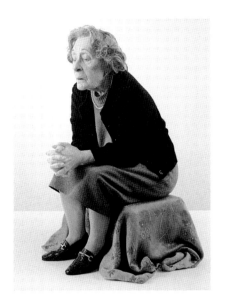

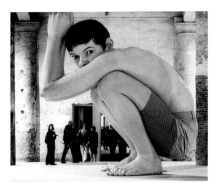

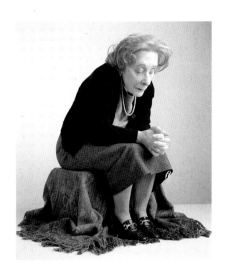

**13  Seated Woman**

1999

Mixed media
Figure: 58 x 28 x 39 cm; 22⁷/₈ x 11 x 15³/₈ in.
Overall: 75 x 62 x 56 cm; 29¹/₂ x 24³/₈ x 22 in.
Ed. 1/1

Museum of Modern Art, Fort Worth

**Exhibitions/Exhibition Catalogues**

1999   Fort Worth, Museum of Modern Art,
       *House of Sculpture,* 23 May – 8 August;
       further venue: Monterrey, Mexico,
       Museo de Arte Contemporáneo de
       Monterrey.
2000   New York, James Cohan Gallery, *Extra
       Ordinary,* 18 May – 30 June, n.cat.

**References**

2002   London, National Gallery, *Ron Mueck,*
       ill. p. 52, comm. by Susanna Greeves p. 53.
2003   Hans Pietsch, "Allein mit sich selbst,"
       *Art,* May, ill. p. 56.

**14  Boy**

1999

Mixed media
490 x 490 x 240 cm; 193 x 193 x 94¹/₂ in.

Kunstmuseum Aarhus

**Exhibitions/Exhibition Catalogues**

2000   London, Millennium Dome, *The Mind
       Zone,* n.cat.
2001   Venice, Corderie, *La Biennale di Venezia,
       49. Esposizione Internazionale d'Arte:
       Platea dell'Umanità/Plateau of
       Humankind,* 10 June – 4 November, vol. 1,
       ill. p. 107, comm. by Michael Wilson
       p. 106.

**References**

2001   Anthony d'Offay Gallery (ed.), *Ron
       Mueck. Boy. Photographs by Gautier
       Deblonde,* London.
       Polly Sutton, "49th Biennale: Ron
       Mueck's 'Boy'," *ABC Arts Online,*
       October.
       *Artforum International,* September,
       ill. on the cover.
2002   London, National Gallery, *Ron Mueck,*
       ill. p. 49, comm. by Susanna Greeves p. 48.
2003   Hans Pietsch, "Allein mit sich selbst,"
       *Art,* May, ill. pp. 62–65.

**15  Seated Woman**

1999/2000

Mixed media
Figure: 58 x 28 x 39 cm; 22⁷/₈ x 11 x 15³/₈ in.
Overall: 75 x 62 x 56 cm; 29¹/₂ x 24³/₈ x 22 in.
A/P

Private collection

**Exhibition/Exhibition Catalogue**

2003   Berlin, Neue Nationalgalerie im Ham-
       burger Bahnhof, Museum für Gegenwart,
       *Ron Mueck,* 10 September – 2 November.

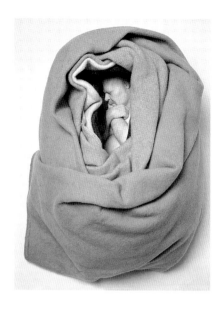

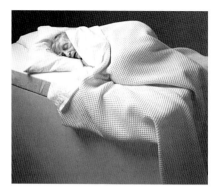

**16 Man in Blankets**

2000

Mixed media

43.1 x 59.7 x 71.2 cm; 17 x 23 ½ x 28 in.

Ed. 1/1

Marguerite and Robert Hoffman, Dallas

**17 Old Woman in Bed**

2000

Mixed media

24 x 94.5 x 56 cm; 9 ½ x 37 ¼ x 22 in.

Ed. 1/1

National Gallery of Canada, Ottawa

**18 Standing Man**

2000

Mixed media

116.8 x 50.8 x 38.1 cm; 46 x 20 x 15 in.

Private collection, Milan

**Exhibition/Exhibition Catalogue**

2000 London, Anthony d'Offay Gallery, *Ron Mueck*, 5 September – 9 December, n.cat.

**References**

2000 Craig Raine, "Ron Mueck," *Areté*, no. 4, winter, comm. pp. 119, 120.

2002 London, National Gallery, *Ron Mueck*, ill. p. 57, comm. by Susanna Greeves pp. 56, 58.

**Exhibitions/Exhibition Catalogues**

2000 London, Anthony d'Offay Gallery, *Ron Mueck*, 15 September – 9 December, n.cat.

2002 Washington DC, Hirshhorn Museum and Sculpture Garden, Smithsonian Institution, *Directions – Ron Mueck*, 18 July – 27 October, ill., comm. by Sidney Lawrence, n.p.

2003 Shawinigan, Quebec, La Cité de l'énergie, *Le Corps Transformé*, 19 June – 15 October, cat. no. 32, ill. p. 57.

2004 Toyota City, Japan, Toyota Municipal Museum of Art, *In Bed – Images from a Vital Stage*, 5 October – 26 December, ill. p. 104.

**References**

2000 Craig Raine, "Ron Mueck," *Areté*, no. 4, winter, comm. p. 121.

2002 London, National Gallery, *Ron Mueck*, ill., comm. by Susanna Greeves p. 58.

**Exhibition/Exhibition Catalogue**

2002 Rome, The British School at Rome, *Heavenly Creatures: Paula Rego and Ron Mueck*, 10 October – 15 November, n.cat.

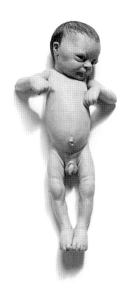

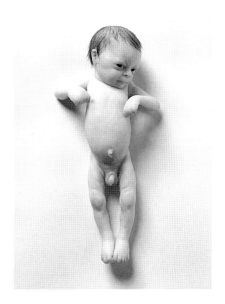

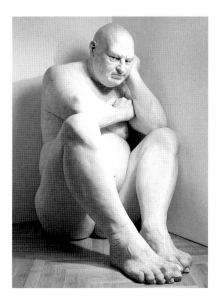

### 19 Baby

2000

Mixed media
26 x 12.1 x 5.3 cm; 10 $^1/_4$ x 4 $^3/_4$ x 2 $^1/_8$ in.
Ed. 1/1

Private collection, New York

**Exhibition/Exhibition Catalogue**

2002  Washington DC, Hirshhorn Museum
and Sculpture Garden, Smithsonian
Institution, *Directions – Ron Mueck*,
18 July – 27 October, ill., comm. by
Sidney Lawrence, n.p.

### 20 Baby

2000

Mixed media
26 x 12.1 x 5.3 cm; 10 $^1/_4$ x 4 $^3/_4$ x 2 $^1/_8$ in.
A/P

Keith and Kathy Sachs, Philadelphia

**Exhibitions/Exhibition Catalogues**

2000  London, Anthony d'Offay Gallery, *Ron
Mueck*, 15 September – 9 December,
n.cat.

2001  Venice, Corderie, *La Biennale di Venezia,
49. Esposizione Internazionale d'Arte:
Platea dell'Umanità/Plateau of Human-
kind*, 10 June – 4 November, vol. 1,
ill. p. 109.

**Reference**

2000  Craig Raine, "Ron Mueck," *Areté*, no. 4,
winter, comm. pp. 117, 118.

### 21 Big Man

2000

Mixed media
205.7 x 117.4 x 209 cm; 81 x 46 $^1/_4$ x 82 $^3/_4$ in.

Hirshhorn Museum and Sculpture Garden,
Smithsonian Institution, Washington DC,
Joseph H. Hirshhorn Bequest Fund, 2001

**Exhibitions/Exhibition Catalogues**

2000  London, Anthony d'Offay Gallery, *Ron
Mueck*, 15 September – 9 December,
n.cat.

2002  Washington DC, Hirshhorn Museum
and Sculpture Garden, Smithsonian
Institution, *Directions – Ron Mueck*,
18 July – 27 October, ill., comm. by
Sidney Lawrence, n.p.

2004  Buffalo, NY, Albright-Knox Art Gallery,
*Bodily Space: New Obsessions in Figura-
tive Sculpture*, 20 April – 7 September.

**References**

2000  Craig Raine, "Ron Mueck," *Areté*, no. 4,
winter, comm. pp. 120, 121.

2002  Roberta Smith, "Art Review. Every
Which Way to Paint," *New York Times*,
30 August, ill. p. 31, weekend section.
London, National Gallery, *Ron Mueck*,
ill. p. 50, comm. by Susanna Greeves
pp. 51, 60.

2003  Hans Pietsch, "Allein mit sich selbst,"
*Art*, May, ill. p. 60.

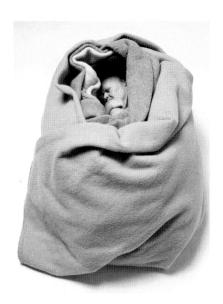

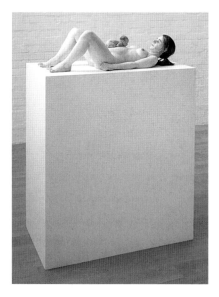

**22  Man in Blankets**

2000/2001

Mixed media
43.1 x 59.7 x 71.2 cm; 17 x 23½ x 28 in.
A/P
Kunstsammlung Nordrhein-Westfalen,
Leihgabe Sammlung Ackermans /
Loan from Sammlung Ackermans

**23  Mother and Child**

2001

Mixed media
24 x 89 x 38 cm; 9½ x 35 x 15 in.

Collection Brandhorst, Germany

**Exhibition/Exhibition Catalogue**

2002  Düsseldorf, K 21 Kunstsammlung im
        Ständehaus, *Startkapital*, inauguration
        18 April, n.cat.

**References**

2002  London, National Gallery, *Ron Mueck*,
        ill. p. 57, comm. by Susanna Greeves
        pp. 56, 58.
        Julian Heynen (ed.), *Sammlung Acker-
        mans: K 21 Kunstsammlung Nordrhein-
        Westfalen*, Düsseldorf, ill. pp. 31, 119.

**Exhibitions/Exhibition Catalogues**

2001  New York, James Cohan Gallery,
        *Ron Mueck*, 12 May – 16 June, n.cat.
2002  Sydney, Museum of Contemporary Art,
        *Ron Mueck*, 19 December 2002 –
        2 March 2003, n.cat.
2003  London, National Gallery, *Ron Mueck.
        Making Sculpture at the National
        Gallery*, 19 March – 22 June, n.n., ill.
        pp. 10–11, 64; 24–27 (work in progress),
        comm. by Colin Wiggins pp. 23–27,
        34–36.
        Berlin, Neue Nationalgalerie im Ham-
        burger Bahnhof, Museum für Gegenwart,
        *Ron Mueck*, 10 September – 2 November.

**References**

2001  Peter Plagens, Ray Sawhill, "Less is
        Mueck," *Newsweek Online*, 25 May.
        Michael Kimmelman, "Veering: From
        the End of Life to the Beginning with
        Lucidity and Awe," *The New York Times*,
        1 June, p. 34, E section.
        Jerry Saltz, "Like Life," *Village Voice*,
        12 June, ill. p. 61.
        Edward Leffingwell, "Ron Mueck at James
        Cohan," *Art in America*, November,
        p. 144.

2003  Angelique Chrisafis, "Pregnant Pause,"
        *The Guardian*, 18 March, ill. p. 13.
        Laura Cumming, "Natal Attraction," *The
        Observer Review*, 23 March, ill. p. 10.
        Martin Gayford, "Umbilically Symbolic,"
        *The Sunday Telegraph*, 23 March, ill. p. 7,
        review section.
        Waldemar Januszczak, "…Ron Mueck
        Sails into History…," *Sunday Times*,
        23 March, ill. p. 7, culture section.
        Hans Pietsch, "Allein mit sich selbst,"
        *Art*, May, ill. p. 65, comm. p. 64.

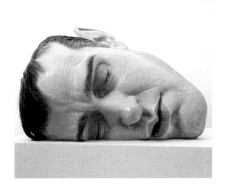

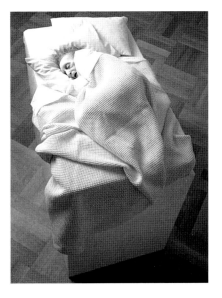

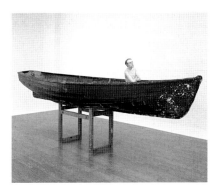

**24  Mask II**
2001

Mixed media
77 x 118 x 85 cm; 30³/₈ x 46¹/₂ x 33¹/₂ in.
Ed. 1/1

Art Supporting Foundation / SF MoMA

**Exhibitions/Exhibition Catalogues**
2001   New York, James Cohan Gallery,
        *Ron Mueck*, 12 May – 16 June, n.cat.
2002   Washington DC, Hirshhorn Museum
        and Sculpture Garden, Smithsonian
        Institution, *Directions – Ron Mueck*,
        18 July – 27 October, n.n., ill., comm. by
        Sidney Lawrence, n.p.

**References**
2001   Jerry Saltz, "Like Life," *Village Voice*,
        12 June, ill. p. 61.
        Roberta Smith, "Art Review: Every
        Which Way to Paint," *New York Times*,
        30 August, ill. p. 27, weekend section.
        Edward Leffingwell, "Ron Mueck at
        James Cohan," *Art in America*,
        November, comm. p. 144.

**25  Old Woman in Bed**
2000/2002

Mixed media
24 x 94.5 x 56 cm; 9¹/₂ x 37¹/₄ x 22 in.
A/P

Art Gallery of New South Wales –
Purchased 2003

**Exhibitions/Exhibition Catalogues**
2002   Sydney, Museum of Contemporary Art,
        *Ron Mueck*, 19 December 2002 –
        2 March 2003, n.cat.
2003   Berlin, Neue Nationalgalerie im Ham-
        burger Bahnhof, Museum für Gegenwart,
        *Ron Mueck*, 10 September – 2 November.

**26  Man in a Boat**
2002

Mixed media
Figure: 75 cm; 29¹/₂ in.
Boat: 421.6 x 139.7 x 122 cm; 166 x 55 x 48 in.

Anthony d'Offay, London

**Exhibitions/Exhibition Catalogues**
2002   Sydney, Museum of Contemporary Art,
        *Ron Mueck*, 19 December 2002 –
        2 March 2003, n.cat.
        London, National Gallery, *Ron Mueck:
        Making Sculpture at the National
        Gallery*, 19 March – 22 June, n.n., ill.
        pp. 12, 13, 65; 29 – 32 (work in progress),
        comm. by Colin Wiggins pp. 27 – 32.
2003   Berlin, Neue Nationalgalerie im Ham-
        burger Bahnhof, Museum für Gegenwart,
        *Ron Mueck*, 10 September – 2 November.
2004   Shawinigan, Quebec, La Cité de l'énergie,
        *Noah's Ark*, 12 June – 3 October, ill. p. 81.

**References**
2003   Angelique Chrisafis, "Pregnant Pause,"
        *The Guardian*, 18 March, ill. p. 13.
        Charles Darwent, "It Looks Real: So Why
        Is It So Spooky?" *The Independent*,
        23 March, ill. p. 8, ArtsEtc. section.
        Waldemar Januszczak, "…Ron Mueck
        Sails into History…," *Sunday Times*,
        23 March, ill. pp. 6, 7, culture section.
        Hans Pietsch, "Allein mit sich selbst,"
        *Art*, May, ill. pp. 52, 53, comm. p. 64.

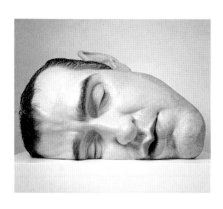

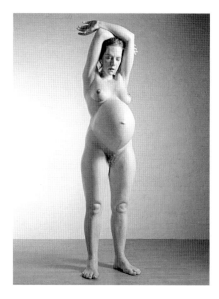

**27  Mask II**

2001/2002

Mixed media
77 x 118 x 85 cm; 30 ³/₈ x 46 ¹/₂ x 33 ¹/₂ in.
A/P

Scottish National Gallery of Modern Art,
Edinburgh

**Exhibitions/Exhibition Catalogues**

2002    Sydney, Museum of Contemporary Art,
        *Ron Mueck,* 19 December 2002 –
        2 March 2003, n.cat.

2003    Berlin, Neue Nationalgalerie im Ham-
        burger Bahnhof, Museum für Gegenwart,
        *Ron Mueck,* 10 September – 2 November.

2004    Toyota City, Japan, Toyota Municipal
        Museum of Art, *In Bed – Images from a
        Vital Stage,* 5 October – 26 December,
        ill. p. 105.

**Reference**

2003    Hans Pietsch, "Allein mit sich selbst,"
        *Art,* May, ill. pp. 54, 55.

**28  Pregnant Woman**

2002

Mixed media
252 x 73 x 68.9 cm; 99 ¹/₄ x 28 ³/₄ x 27 ¹/₈ in.

National Gallery of Australia, Canberra
Purchased with the assistance of Tony and
Carol Berg 2003

**Exhibitions/Exhibition Catalogues**

2002    Sydney, Museum of Contemporary Art,
        *Ron Mueck,* 19 December 2002 –
        2 March 2003, n.cat.

2003    London, National Gallery, *Ron Mueck.
        Making Sculpture at the National
        Gallery,* 19 March – 22 June, n.n., ill.
        pp. 15, 66; 34–37 (work in progress),
        comm. by Colin Wiggins pp. 32–36.
        Berlin, Neue Nationalgalerie im
        Hamburger Bahnhof, Museum für
        Gegenwart, *Ron Mueck,* 10 September –
        2 November.

2005    Melbourne, National Gallery of Victoria,
        *Ron Mueck. The Making of Pregnant
        Woman 2002,* 29 January – 27 February;
        Further venue: Queensland Art Gallery,
        12 March – 5 June.

**References**

2003    Peter Hill, "Ron Mueck, MCA," *Sydney
        Morning Herald,* 3 January, ill.
        Angelique Chrisafis, "Pregnant Pause,"
        *The Guardian,* 18 March, ill. p. 13.
        Charles Darwent, "It Looks Real: So Why
        Is It So Spooky?" *The Independent,*
        23 March, ill., comm. p. 8, ArtsEtc.
        section.
        Hans Pietsch, "Allein mit sich selbst,"
        *Art,* May, ill. pp. 58, 59, comm. p. 64.

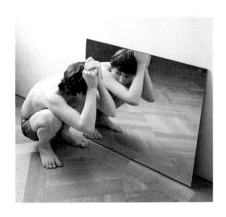

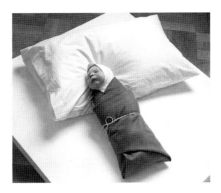

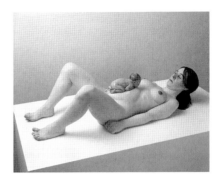

**29 Crouching Boy in Mirror**
1999/2002

Mixed media
Boy: 43.2 x 45.7 x 28 cm; 17 x 18 x 11 in.
Mirror: 45.7 x 55.9 x 0.6 cm; 18 x 22 x ¼ in.

Private collection

**Exhibitions/Exhibition Catalogues**
2002   Sydney, Museum of Contemporary Art,
       *Ron Mueck*, 19 December 2002 –
       2 March 2003, n.cat.
2003   Berlin, Neue Nationalgalerie im Ham-
       burger Bahnhof, Museum für Gegenwart,
       *Ron Mueck*, 10 September – 2 November.

**30 Swaddled Baby**
2002

Mixed media
Baby: 18.4 x 21.6 x 49.5 cm; 7 ¼ x 8 ½ x 19 ½ in.
Pillow: 15.2 x 73.7 x 44.5 cm; 6 x 29 x 17 ½ in.

Private collection

**Exhibitions/Exhibition Catalogues**
2002   Sydney, Museum of Contemporary Art,
       *Ron Mueck*, 19 December 2002 –
       2 March 2003, n.cat.
2003   London, National Gallery, *Ron Mueck:
       Making Sculpture at the National
       Gallery*, 19 March – 22 June, n.n., ill.
       pp. 17, 67; 39–41 (work in progress),
       comm. by Colin Wiggins pp. 37–41.
       Berlin, Neue Nationalgalerie im Ham-
       burger Bahnhof, Museum für Gegenwart,
       *Ron Mueck*, 10 September – 2 November.

**References**
2003   John Russell Taylor, "All Mueck and
       Magic," *The Times*, 19 March, ill. p. 15,
       T2 section.
       Waldemar Januszczak, "…Ron Mueck
       Sails into History…," *Sunday Times*,
       23 March, ill. p. 6, culture section.
       Hans Pietsch, "Allein mit sich selbst,"
       *Art*, May, ill. p. 61.

**31 Mother and Child**
2001/2004

Mixed media
24 x 89 x 38 cm; 9½ x 35 x 15 in.
A/P

Collection of the Robert Lehrmann Art Trust,
Washington, DC
Courtesy of Aimee and Robert Lehrmann

**Exhibition/Exhibition Catalogue**
2005   Boston, The Institute of Contemporary
       Art, *Getting Emotional*, 18 May –
       5 September, ill. pp. 106, 107.

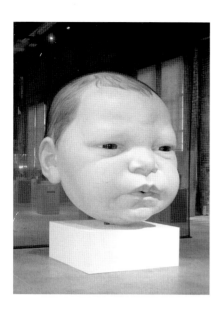

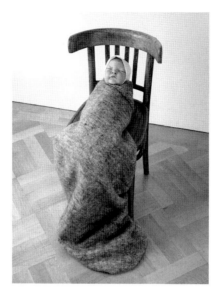

**32   Head of a Baby**

2003

Mixed media
254 x 219 x 238 cm; 100 x 86¹/₄ x 93³/₄ in.

National Gallery of Canada, Ottawa

**33   Baby on a Chair**

2004

Mixed media
Baby: 18.4 x 21.6 x 49.5 cm; 7¹/₄ x 8¹/₂ x 19¹/₂ in.
Chair: 77 x 36 cm; 30¹/₄ x 14¹/₈ in.

Collection Glenn Fuhrman, New York

**Exhibition/Exhibition Catalogue**

2003   Shawinigan, Quebec, La Cité de l'énergie,
       *Le Corps Transformé,* 19 June – 15 Octo-
       ber, cat. no. 33, ill. pp. 58, 59.

**Fotonachweis / Photo Credits**

Für die Reproduktionsvorlagen der Werke von Ron Mueck, wenn nicht anders angegeben /
Unless otherwise indicated, reproductions of Ron Mueck's works: Courtesy Anthony d'Offay.
Acropolis Museum / Hellenic Ministery of Culture, Athens, S. / p. 15; Will Brown, Philadelphia,
S. / pp. 66, 77; Galleria dell' Accademia, Venice, S. / p. 32; © GAUTIER DEBLONDE, S. / pp. 84, 85;
Barbara Klemm/Frankfurter Allgemeine Zeitung, S. / pp. 8, 75; Bernd Kunert, Berlin, S. / p. 63,
Umschlagabbildung / Front cover; Kunstmuseum Basel, Öffentliche Kunstsammlung Basel /
Martin Bühler, S. / p. 17; Museo Diocesano, Valladolid, S. / p. 17; The National Gallery, S. / p. 33;
The National Gallery of Canada / Canadian Museum of Contemporary Photography, S./pp. 68, 82;
www.perouinc.com, S. / pp. 52, 53; Courtesy Sammlung Ackermans / Kunstsammlung Nordrhein-
Westfalen, Düsseldorf, S. / p. 78; Courtesy Sammlung Olbricht, S. / p. 43; St. Baafskathedraal,
Ghent / Paul M. R. Maeyaert, S. / p. 16.

Ron Mueck wurde 1958 in Melbourne geboren. Seine aus Deutschland eingewanderten Eltern waren als Spielzeugmacher tätig. Von 1979 bis 1983 arbeitete Ron Mueck für Kinderprogramme im Fernsehen. 1986 hielt er sich für ein halbes Jahr in Los Angeles auf und zog anschließend nach London, wo er – unter anderem für den Fantasyfilm *Labyrinth* mit David Bowie – für Special Effects zuständig war. 1990 gründete Ron Mueck seine eigene Produktionsfirma und stellte bis 1996 Puppen für europäische Werbekampagnen her. In dieser Zeit begann er, mit Fiberglasharz zu arbeiten, einem Material, das in seiner folgenden, künstlerischen Arbeit überwiegend Verwendung finden sollte.

Seit 1996 ist Ron Mueck als freier Bildhauer tätig. Im selben Jahr nahm eine größere Öffentlichkeit zum ersten Mal eine seiner Skulpturen wahr, als Paula Rego in der Ausstellung *Spellbound: Art and Film*, Hayward Gallery, London, überraschenderweise in einem Raum ihrer Bilder auch Muecks Werk *Pinocchio* ausstellte. Muecks künstlerischer Durchbruch erfolgte 1997 mit seinem Beitrag für die Gruppenausstellung *Sensation: Young British Artists from the Saatchi Collection* in der Royal Academy, London. Im Februar 2000 wurde er für zwei Jahre als Associate Artist (artist in residence) an die National Gallery, London, berufen. In einem Atelier des Museums entstanden die Skulpturen *Mother and Child*, *Man in a Boat* und *Crouching Boy in Mirror*. Im Herbst 2003 zeigte die Neue Nationalgalerie im Hamburger Bahnhof, Museum für Gegenwart – Berlin, Ron Muecks erste umfassende Einzelausstellung in Deutschland. Der Künstler lebt und arbeitet in London.

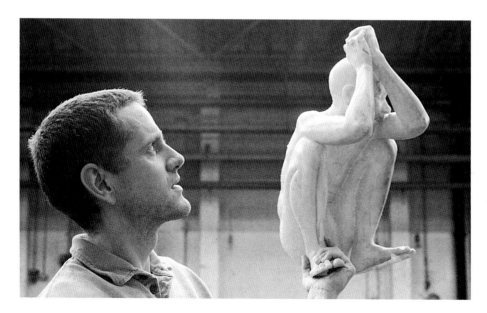

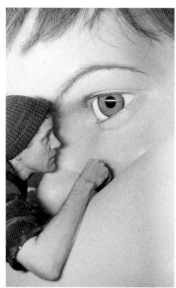

Ron Mueck was born in Melbourne in 1958. His parents, of German descent, had immigrated to Australia. They were both toy makers. From 1979 to 1983, Ron Mueck worked in children's television production. In 1986, he lived for six months in Los Angeles and then moved to London, where he created special effects for such films as *Labyrinth*, a fantasy epic starring David Bowie. Between 1990 and 1996, Ron Mueck had his own production company in London, making models for the advertising industry in Europe. During this period, he began using fiberglass resin, which was to become the staple material of his artistic practice.

Since 1996 he has been making sculptures independently. In that year he participated in the exhibition *Spellbound: Art and Film* at the Hayward Gallery in London with the sculpture *Pinocchio*, which Paula Rego had surprisingly included in the installation of her paintings. Ron Mueck's breakthrough came in 1997 with his participation in *Sensation: Young British Artists from the Saatchi Collection* at the Royal Academy, London. In February 2000, he was appointed Associate Artist at the National Gallery, London, a residency which lasted for two years. In a studio at the National Gallery he made the sculptures *Mother and Child*, *Man in a Boat*, and *Crouching Boy in Mirror*. In autumn 2003, the Neue Nationalgalerie presented the first extensive solo exhibition in Germany at the Hamburger Bahnhof, Museum für Gegenwart—Berlin, which traveled to the Frans Hals Museum in Haarlem. The artist lives and works in London.

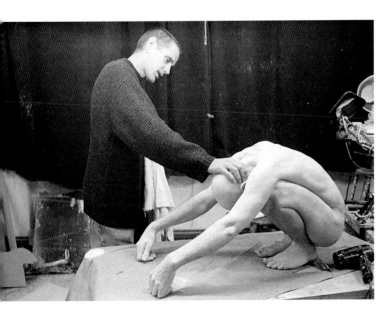
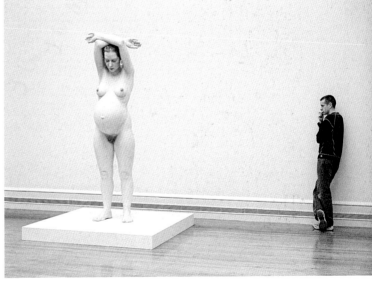

# Ausgewählte Literatur / Selected Bibliography

**References: Books and Articles**

1996 John McEwen, "Something Disturbing in Silicon," *The Sunday Telegraph*, 18 February.

1997 Louise Bishop, "Model Family," *Creative Review*, April, pp. 36–38.

Shaun Phillips, "Big Ron, Little Ron," *The Face*, June, pp. 106–112.

Judith Bumpus, "Do You Believe in Fairies? Ron Mueck, Sculptor," artist's statement, *RA Magazine*, winter, p. 35.

1998 The Saatchi Gallery (ed.), *The New Neurotic Realism*, London.

Regina von Planta, "Ron Mueck bei Anthony d'Offay," *Kunst-Bulletin*, May.

Waldemar Januszczak, "Invasion of the Body Watchers," *The Sunday Times*, 31 May, p. 8, culture section.

Judith Palmer, "Eyeball to Eyeball with Mueck and his Works," *The Independent*, 2 June, p. 3.

Louisa Buck, "The Americans Are Coming: Cindy Sherman, James Turrell, and Sol LeWitt Come to Town plus Ron Mueck's…," *Art Newspaper*, no. 82, June, p. 54.

Brooks Adams, "Sensation's Sensation," *Interview*, July.

Terry R. Myers, "Ron Mueck," *Art/Text*, 26 August, pp. 84, 85.

Claire Bishop, "Ron Mueck," *Flash Art*, October, p. 126.

Craig Raine, "To the Life," *Modern Painters*, autumn, pp. 20–23.

1999 Richard Cork, Sarah Kent, and Jonathan Barnbrook (eds.), *Young British Art: The Saatchi Decade*, London, pp. 381–385, 494, 495.

Martin Gayford, "A Disconcerting World," *Harpers & Queen*, January.

Martin Gayford, "Visitors from Another World," *The Daily Telegraph*, 27 May, p. 22.

2000 Andrew Graham-Dixon, "Father Figure," *Sunday Telegraph Magazine*, 16 April, pp. 20, 21.

Waldemar Januszczak, "Still a Sensation," *The Sunday Times*, 17 September, p. 7.

Jörg Restorff, "Flügelwesen und Bruchpiloten: Von guten und bösen Engeln," *Kunstzeitung*, no. 52, December, p. 1.

Craig Raine, "Ron Mueck," *Areté*, no. 4, winter, pp. 117–121.

2001 Martin Herbert, "Ron Mueck," *Tema Celeste*, January/February, p. 87.

Peter Plagens, Ray Sawhill, "Less Is Mueck," *Newsweek Online*, 25 May.

Michael Kimmelman, "Veering: From the End of Life to the Beginning with Lucidity and Awe," *The New York Times*, 1 June, p. 34, E section.

Edith Newhall, "Naked Truth," *New York Magazine*, 4 June.

Kim Levin, "Ron Mueck," *The Village Voice*, Voice Choices, 5 June.

"Review: Galleries Uptown, Ron Mueck," *The New York Times*, 8 June.

Jerry Saltz, "Like Life," *The Village Voice*, 12 June, p. 61.

*Artforum International*, September, front page.

Polly Sutton, "49th Biennale: Ron Mueck's 'Boy'," *ABC Arts Online*, October.

Edward Leffingwell, "Ron Mueck at James Cohan," *Art in America*, November, p. 144.

Michaël Amy, "New York – Ron Mueck: James Cohan Gallery," *Sculpture*, December, pp. 72, 73.

2002 Roberta Smith, "Every Which Way to Paint," *New York Times*, 30 August, pp. 27, 31, weekend section.

Julian Heynen (ed.), *Sammlung Ackermans, K 21 Kunstsammlung Nordrhein-Westfalen*, Düsseldorf, pp. 31, 119.

2003 Peter Hill, "Ron Mueck, MCA," *Sydney Morning Herald*, 3 January.

Angelique Chrisafis, "Pregnant Pause," *The Guardian*, 18 March, ill. p. 13.

John Russel Taylor, "All Mueck and Magic," *The Times*, 19 March, p. 15, T2 section.

Laura Cumming, "Natal Attraction," *The Observer Review*, 23 March, p. 10.

Charles Darwent, "It Looks Real: So Why Is It So Spooky?," *The Independent*, 23 March, ill., comm. p. 8, ArtsEtc. section.

Martin Gayford, "Umbilically Symbolic," *The Sunday Telegraph*, 23 March, p. 7, review section.

Waldemar Januszczak, "… Ron Mueck Sails into History…," *Sunday Times*, 23 March, ill. pp. 6, 7, culture section.

Hans Pietsch, "Allein mit sich selbst," *Art*, May, pp. 52–65.

Jonathan Cape and The Saatchi Gallery (eds.), *100 – The Work That Changed British Art*, London, pp. 152–159, comm. by Patricia Ellis, pp. 212, 213.

## Exhibitions / Exhibition Catalogues

### Solo Exhibitions

**1998** London, Anthony d'Offay Gallery, *Ron Mueck*, 29 April – 18 June.

**2000** London, Anthony d'Offay Gallery, *Ron Mueck*, 15 September – 9 December.

**2001** New York, James Cohan Gallery, *Ron Mueck*, 12 May – 16 June.

**2002** Washington DC, Hirshhorn Museum and Sculpture Garden, Smithsonian Institution, *Directions – Ron Mueck*, curated by Sidney Lawrence, 18 July – 27 October, brochure, n.p.

Sydney, Museum of Contemporary Art, *Ron Mueck*, 19 December 2002 – 2 March 2003.

**2003** London, National Gallery, *Ron Mueck: Making Sculpture at the National Gallery*, curated by Colin Wiggins, 19 March – 22 June, cat., texts by Colin Wiggins pp. 19–41 and Susanna Greeves pp. 43–62.

Berlin, Neue Nationalgalerie im Hamburger Bahnhof, Museum für Gegenwart, *Ron Mueck*, 10 September – 2 November, cat; further venue: Haarlem, Frans Hals Museum, 15 November 2003 – 18 January 2004.

### Group Exhibitions

**1996** London, Hayward Gallery, *Spellbound: Art and Film*, curated by Philip Dodd and Ian Christie, 22 February – 6 May, cat.

**1997** London, Royal Academy of Arts, *Sensation: Young British Artists from the Saatchi Collection*, curated by Norman Rosenthal, 18 September – 28 December; cat., pp. 126, 127; further venues: Berlin, Neue Nationalgalerie im Hamburger Bahnhof, Museum für Gegenwart, *Sensation: Junge Britische Künstler aus der Sammlung Saatchi*, 30 September 1998 – 17 January 1999, cat., pp. 126, 127; New York, The Brooklyn Museum of Art, 2 October 1999 – 9 January 2000 (London and New York, one cat.).

**1999** San Francisco, California College of Arts and Crafts, *Spaced Out: Late 1990s Works from the Vicki and Kent Logan Collection*, curated by Lawrence Rinder, 17 April – 5 June, cat. p. 29, comm. pp. 7, 8.

Fort Worth, Museum of Modern Art, *House of Sculpture*, curated by Michael Auping, 23 May – 8 August; further venue: Monterrey, Mexico, Museo de Arte Contemporáneo de Monterrey.

Kiel, Kunsthalle zu Kiel, *Unsichere Grenzen*, curated by Beate Ermacora, 17 June – 29 August, cat., pp. 18, 19, comm. pp. 20, 21.

Düsseldorf, Kunsthalle, *Heaven*, curated by Doreet Levitte Harten, 30 July – 17 October, cat., pp. 42, 43; further venue: Liverpool, Tate Gallery, 9 December 1999 – 27 February 2000 (Düsseldorf and Liverpool, one cat.).

**2000** London, Millennium Dome, *The Mind Zone*.

London, The Saatchi Gallery, *Ant Noises at the Saatchi Gallery: Part I, Damien Hirst, Sarah Lucas, Ron Mueck, Chris Ofili, Jenny Saville, Rachel Whiteread*, 20 April – 20 August, cat., n.p.

New York, James Cohan Gallery, *Extra Ordinary*, 18 May – 30 June.

**2001** Bremen, Neues Museum Weserburg and Gesellschaft für Aktuelle Kunst, *Ohne Zögern: Die Sammlung Olbricht Teil 2 – Without Hesitation: The Olbricht Collection, Part 2*, curated by Peter Friese and Eva Schmidt, 3 June – 16 September, cat., p. 183, comm. by Sabine Maria Schmidt pp. 182, 183.

Venice, Giardini di Castello, Arsenale, *La Biennale di Venezia, 49. Esposizione Internazionale d'Arte: Platea dell' Umanità/Plateau of Humankind*, curated by Harald Szeemann, 10 June – 4 November, cat., pp. 107–109, comm. by Michael Wilson p. 106.

**2002** Essen, Ruhrlandmuseum, *Ebenbilder: Kopien von Körpern – Modelle des Menschen*, curated by Jan Gerchow, 26 March – 30 June, cat., p. 280.

Rotterdam, Museum Boijmans Van Beuningen, *Imagine, You Are Standing Here in Front of Me: Caldic Collectie*, 23 November 2002 – 2 February 2003, cat., p. 190.

Rome, The British School at Rome, *Heavenly Creatures: Paula Rego and Ron Mueck*, 10 October – 15 November.

Tokyo, The National Museum of Art, *A Perspective on Contemporary Art: Continuity and Transgression*, 29 October – 23 December, cat., n.p.; further venue: Osaka, The National Museum of Osaka, 16 January – 23 March 2003 (Tokyo and Osaka, one cat.).

Düsseldorf, K 21 Kunstsammlung im Ständehaus, *Startkapital*, inauguration: 18 April, cat., pp. 31, 119.

**2003** Berlin, Berliner Medizinhistorisches Museum der Charité, *Gewissenlos – Gewissenhaft: Menschenversuche im Konzentrationslager*, 24 April – 27 July, cat.

Helmond, Gemeentemuseum, *Child in Time: Views of Contemporary Artists on Youth and Adolescence*, 24 May – 7 September, cat., p. 8.

Shawinigan, Quebec, La Cité de l'énergie, *Le corps transformé*, 19 June – 15 October.

**2004** Buffalo, NY, Albright-Knox Art Gallery, *Bodily Space. New Obsessions in Figurative Sculpture*, 20 April – 7 September.

Fellbach, Alte Kelter, *Ich will, dass du mir glaubst! 9. Triennale Kleinplastik Fellbach 2004*, 26 June – 3 October.

Toyota City, Japan, Toyota Municipal Museum of Art, *In Bed. Images from a Vital Stage*, 5 October – 26 December.

**2005** Boston, The Institute of Contemporary Art, *Getting Emotional*, 18 May – 5 September.

Die Erstausgabe dieser Publikation erschien anlässlich der Ausstellung / The first edition of this catalogue was published in conjunction with the exhibition RON MUECK
Neue Nationalgalerie im Hamburger Bahnhof, Museum für Gegenwart – Berlin
10 September – 2 November 2003

2. revidierte, erweiterte Auflage / Second, revised and expanded edition 2005

Herausgeber / Editor HEINER BASTIAN
Catalogue raisonné CÉLINE BASTIAN
Mitarbeit / Assistance LAETITIA VON BAEYER, CAROLINE KÄDING
Übersetzungen / Translations ANNE D'OFFAY (HEINER BASTIAN), MARION KAGERER (SUSANNA GREEVES)
Lektorat / Copyediting UTE BARBA (Deutsch/German), INGRID NINA BELL, TAS SKORUPA (Englisch / English)
Grafische Gestaltung / Graphic design ANDREAS PLATZGUMMER
Satz / Typesetting WEYHING DIGITAL, Ostfildern-Ruit
Schrift / Typeface Akzidenz Grotesk medium, Aldus
Reproduktion / Reproduction REPROMAYER, Reutlingen
Papier / Paper LuxoArtSilk 170 g/m²
Buchbinderei / Binder CONZELLA VERLAGSBUCHBINDEREI, Urban Meister GmbH, Aschheim-Dornach

Gesamtherstellung / Printed by DR. CANTZ'SCHE DRUCKEREI, Ostfildern-Ruit

Umschlagabbildung / Cover illustration: *Crouching Boy in Mirror,* 1999/2002
Frontispiz / Frontispiece: *Mask II,* 2001/2002 (A/P)
Umschlagrückseite / Back cover: *Pregnant Woman,* 2002 (Detail /detail)

Erschienen im / Published by
HATJE CANTZ VERLAG
Senefelderstraße 12
73760 Ostfildern-Ruit
Deutschland / Germany
Tel. +49 711 4405-0
Fax +49 711 4405-220
www.hatjecantz.com

Hatje Cantz books are available internationally at selected bookstores and from the following distribution partners:

USA/North America – D.A.P., Distributed Art Publishers, New York, www.artbook.com
UK – Art Books International, London, sales@art-bks.com
Australia – Tower Books, Frenchs Forest (Sydney), towerbks@zipworld.com.au
France – Interart, Paris, commercial@interart.fr
Belgium – Exhibitions International, Leuven, www.exhibitionsinternational.be
Switzerland – Scheidegger, Affoltern am Albis, scheidegger@ava.ch

For Asia, Japan, South America, and Africa, as well as for general questions, please contact Hatje Cantz directly at sales@hatjecantz.de, or visit our homepage www.hatjecantz.com for further information.

ISBN 3-7757-1719-6
Printed in Germany